BUXTON
IN 50
BUILDINGS

DAVID MORTEN

AMBERLEY

Acknowledgements

Many thanks to Lorna Talbott for her valuable research and literary contributions. I would like to acknowledge the help and advice I have had in the preparation of this book from Oliver Gomersal and Colin Wells, and also access to the research done by Colin and the late Mike Langham. Trevor Gilman, Joanne Hibbert and Janet Byers of the Buxton Group for their advice and also the use of Joanne's extensive collection of postcards.

First published 2018

Amberley Publishing, The Hill, Stroud
Gloucestershire gl5 4EP

www.amberley-books.com

British Library Cataloguing in Publication Data.
A catalogue record for this book is available from the British Library.

ISBN 978 1 4456 7893 1 (print)
ISBN 978 1 4456 7894 8 (ebook)

Origination by Amberley Publishing.
Printed in Great Britain.

Contents

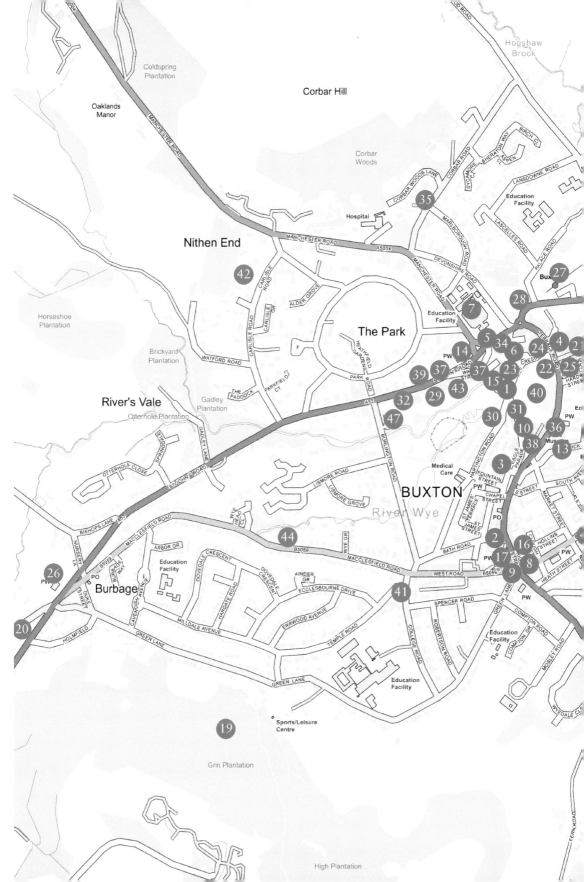

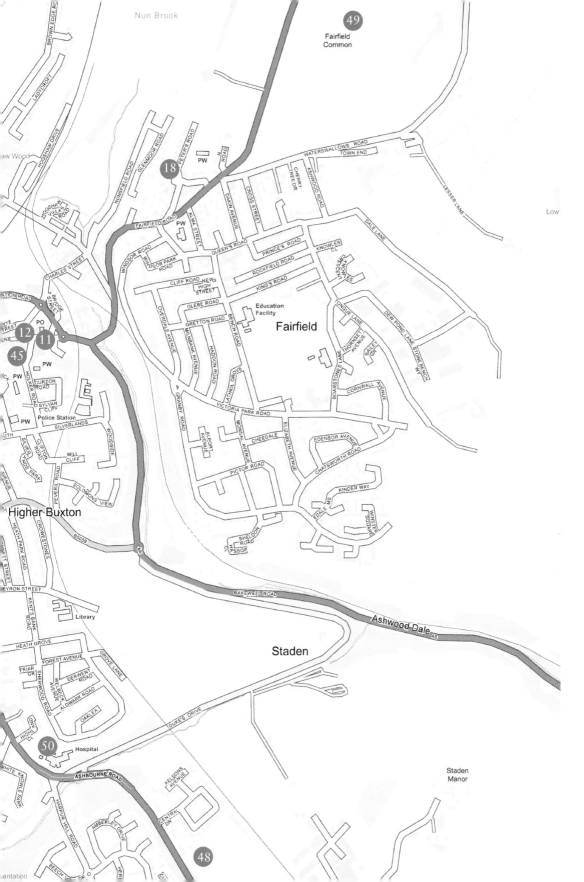

Key

Introduction

Buxton is the highest market town in Britain, with the greater part standing at over 1,000 feet above sea level, yet it is built in a valley surrounded by hills with an elevation of 1,500 feet or more. These hills temper the severity of the winds, and their wooded slopes enrich the surrounding landscapes. The town is situated on the northern edge of the limestone dome and is surrounded by a great horseshoe of grit hills including Axe Edge and Kinder Scout. This conjunction of limestone and gritstone leads to Buxton's reason for existence, namely the thermal springs that bubble up beneath the Crescent in the centre of the town.

The Romans came to Buxton around AD 79 and called the settlement 'Aquae Arnemetiae', meaning 'The Spa of the Goddess of the Grove'. The Romans only gave two places in Britain the prefix 'Aquae', the other being Aquae Sulis, known today as Bath. The remains of a Roman milestone were found at Silverlands in 1862 and evidence of a Roman settlement was uncovered at Lismore Fields during the construction of a housing development. Further evidence of the Roman occupation came to light during the excavation of the site of the thermal springs in 1975 when over 200 coins spanning the rules of several emperors were found. Today archaeologists investigate most new building sites as a matter of routine.

Following the departure of the Romans Buxton sank back into obscurity, being considered a wild, remote and desolate place. Nothing more was heard of Buxton until the Middle Ages, when once again the warm springs brought visitors to the area.

The springs, which rise in several places in the area by the Crescent, have been giving an endless flow of water at 82 degrees Fahrenheit for thousands of years – brought up to burst through the ground at nearly 1,000 feet above sea level by hydrostatic pressure. Had it not been for the presence of the waters, Buxton would have remained a small village compared to its larger neighbour at the time: Fairfield.

The Elizabethans did much to enhance the reputation of the town, with the building of the Old Hall and the visits of Mary, Queen of Scots, but it was the Georgians with the investments of the 5th Duke of Devonshire between 1780 and 1811 that left the town with a splendid legacy of buildings such as the Crescent, stables, church and town houses.

Following the coming of the railways in 1862 Buxton's reputation as an inland resort soared and by 1905 twenty-seven hotels and more than 300 lodging houses provided facilities for a weekly influx of 4,000 visitors.

Buxton's location on the edge of the limestone dome has always provided the other main source of employment other than catering for visitors: quarrying and lime burning. From the early days of individual kilns built on the side of the hill at Grinlow, alternate layers of coal and wood (found locally) and limestone would be fired for several days, before the resulting quicklime would be allowed to cool, drawn off, and loaded into panniers on packhorses and transported over the trails to Cheshire and beyond to the massive quarries

of today, blasting millions of tons a year from the surrounding hillsides and transported by road and rail to the far ends of the country.

Today, with the forthcoming reopening of the Crescent as a major spa experience, the International Opera Festival going from strength to strength, the marketing of Buxton Water and the growing presence of the University of Derby, it seems as though Buxton's future in the twenty-first century is secure.

The 50 Buildings

1. The Old Hall Hotel, 1573

The settlement at Buxton is ancient. The geothermal spring has always attracted visitors and the Romans had a town near the spring for the whole of their occupation of Britain. No Roman buildings now remain.

Throughout medieval times the legend of the 'warm and honeyed waters' at 'Bawkestanes' passed by word of mouth, and a shrine was created and dedicated to Saint Anne. The shrine was forcibly closed with the Dissolution of the Monasteries but reopened later. Those of poor health could visit the shrine, take the waters and hopefully recover. As Buxton was quite remote and the population in the area quite small it was not until 1573 that definite reference was made to a property being nearby. This is the first mention of the building that was originally called the Auld Hall.

The Old Hall Hotel has changed its name many times in the past. It has been known as the New Hall and Buxton Hall Hotel before it became the Old Hall Hotel, which it is called

Old Hall Hotel.

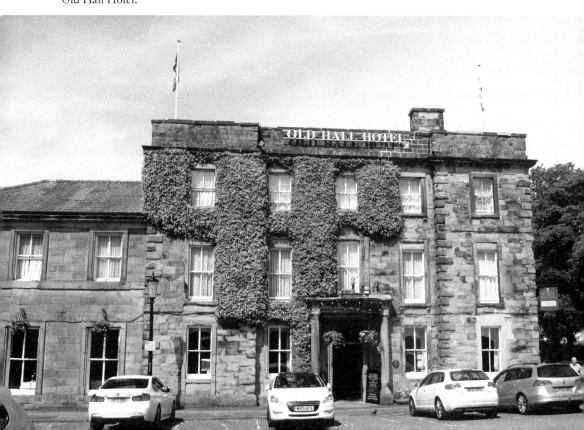

to this day. Reputedly the oldest hotel in England, it has a long history of offering food and accommodation to noted guests.

The erection of the original building was sanctioned by Elizabeth I. Primarily it was to offer accommodation to Mary, Queen of Scots while she was under house arrest and in the custody of the earls of Shrewsbury. The earls of Shrewsbury were local to Derbyshire and knew of the healing waters at Buxton as the family had taken the waters themselves. Buxton was a good site for a large house.

In 1572–73 the 6th Earl of Shrewsbury ordered the building of the 'New Hall', described at the time as 'a very goodly house, four square, four stories high, with a great chamber, and other goodly lodgings to about thirty'. The building was impressive to Tudor society.

George Talbot was the 6th Earl of Shrewsbury and a major landowner in the north of England. He was one of Elizabeth's most trusted courtiers and therefore the custody of Mary was given to him in 1569. He had married Bess of Hardwick (who built Hardwick Hall and Chatsworth) in 1568, which gave him access to her vast estates and wealth.

Mary, Queen of Scots was plagued by rheumatism and she stayed a number of times as a 'guest' in the tower of the Old Hall, and often took the waters between the years of 1573 and 1584. On Mary's final visit she scratched – in Latin – an inscription upon a window in the hotel. This inscription translates as: 'Buxton, whose warm waters have made thy name famous, perchance I shall visit thee no more. Farewell.' The message from Mary can still be seen, scratched on the window in Room 26 of the hotel.

In 1670 the building was rebuilt as a hotel, Buxton Hall Hotel, around the original central tower of 1573. This central tower still survives today.

Old Hall Hotel from the south showing the later additions with the dome of the Devonshire Hospital behind.

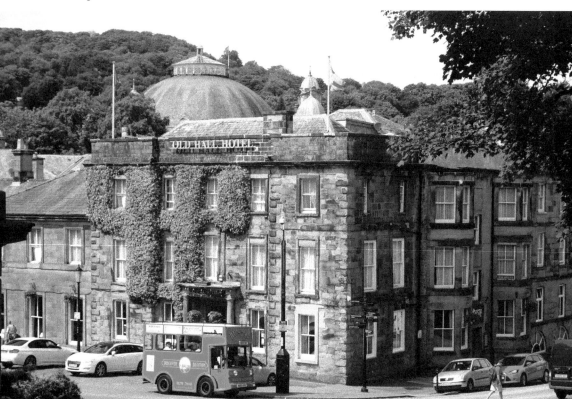

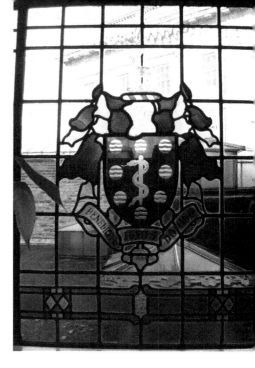

Window in the Old Hall Hotel showing the Buxton town crest.

The hotel was visited by author Daniel Defoe in 1727 while on his grand tour through the whole of Great Britain and he said he must 'give praise to Buxton's warm springs for their medicinal virtue'. By the turn of the nineteenth century, Buxton, and the merit of its waters, had become well known and the town was a thriving spa. The fashionable aristocracy lodged at the Buxton Hall Hotel while taking the waters.

The Old Hall Hotel had extensive grounds to the front, which were for the use of the guests for recreational purposes. The Duke of Devonshire, who still owned the hotel, gave 9 acres of these grounds to the town of Buxton in 1871. These were to be held in perpetuity on condition they were to be used exclusively for the purposes of recreation. Eventually this recreational parkland was extended to the present 23 acres, by ducal gifts given later and form the present Pavilion Gardens. These are used, as wished by the Duke of Devonshire, for the 'recreational purposes' of the many visitors and residents of the town.

The Old Hall Hotel is still welcoming to visitors today, who can relax in surroundings once enjoyed by a queen. In addition to the Mary, Queen of Scots window a lovely stained-glass window showing the Buxton town crest can be seen inside.

2. St Anne's Church, Bath Road, 1625

This lovely stone-built church was originally dedicated to St John the Baptist. It is one of the oldest buildings in Buxton and certainly the oldest church.

The date '1625' is carved over the porch but architectural evidence suggests that the major part of the building is of a far earlier date. It is believed that the main part of the building was originally built as a tithe barn and its purpose adapted to create a place of worship.

Inside the church, the original roof beams can be seen. The date of '1625' is also carved on the square font that is situated near the entrance door, but this is believed to have been carved in error to correspond with the date on the porch. The font is probably of Saxon origin and has been moved to St Anne's from another earlier church.

Above: St Anne's Church.

Below: Old postcard showing the northern side of St Anne's Church.

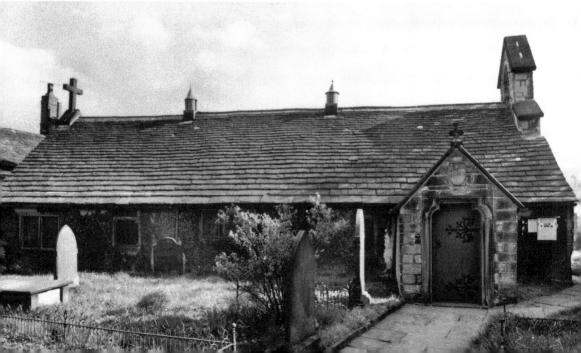

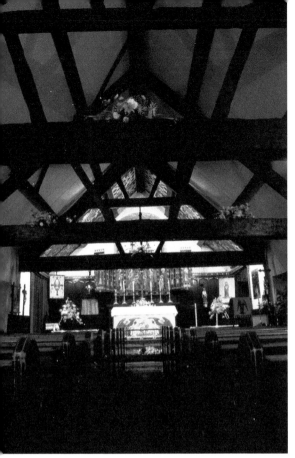

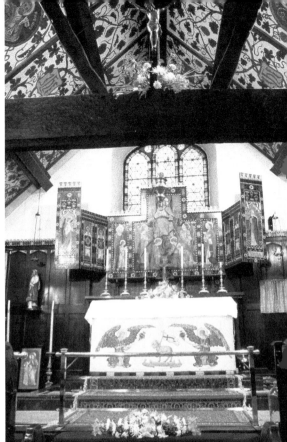

Above left: Interior of St Anne's Church.

Above right: Altar and triptych at St Anne's Church.

Right: Altar, St Anne's Church.

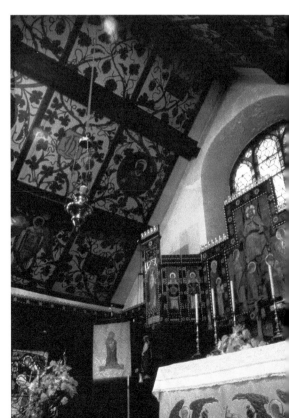

In 1715, extensions were made and a vestry added, but by the end of the century the church had become ruinous. Services were transferred to the newly built Assembly Rooms until a new church could be built in 1811. The dedication to St John was transferred to this new church.

The original 1625 church was no longer consecrated but it was repaired and became first a school, then a Sunday school and then a mortuary chapel. The building reopened as a church in 1885 and was dedicated to St Anne. It became known as the High Church of Buxton due to the marked ritualism of the Catholic services.

Tomb of John Kane

This gravestone for John Kane is a listed monument. Many tourists visit the site to see the last resting place of the eighteenth-century actor who, as local folklore has it, literally 'ate himself to death'.

John Kane's unfortunate demise occurred while the actor was performing at the Buxton Opera House. John Kane was an eighteenth-century actor and comedian of considerable distinction who tragically died in curious circumstances in 1799. According to popular belief, Kane had a large appetite and particularly enjoyed roast beef with horseradish sauce. On the fated evening in 1799, the cook who prepared the dinner for Kane had accidentally gathered Conium maculatum (the European species of hemlock) instead of wild horseradish to make the relish for his favourite dish. Kane died soon after from hemlock poisoning. The grave can be seen at the rear of St Anne's churchyard in Buxton.

Tomb of John Kane, St Anne's churchyard.

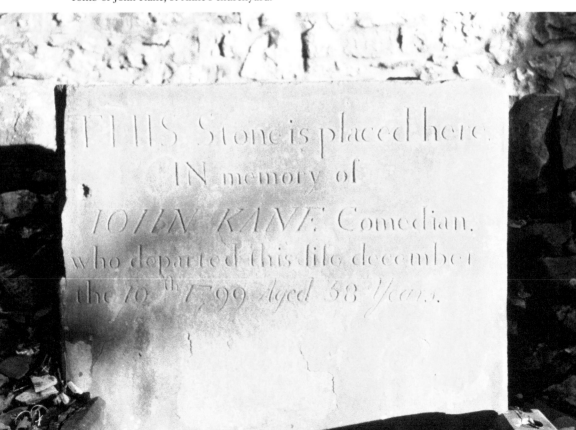

3. The Eagle Hotel, Market Place, 1760

Now a popular 'real ale' pub, the Grade II-listed Eagle Hotel was originally called the Eagle and Child and it was first recorded in 1592.

The original building in the marketplace was purchased by the 3rd Duke of Devonshire in 1746 and rebuilt by the 5th Duke in 1760. Further extensions were made between 1780 and 1790.

In the late eighteenth century it served as a coaching inn. The main Manchester to London coach route passed through Buxton and hostelries in the town competed for business. To please all the traders a satisfactory compromise was needed. It was agreed by the Eagle Hotel and rival inn the White Hart that those passengers travelling south to London ate at the White Hart, while those travelling north towards Manchester had the honour of dining at the Eagle.

After the loss in popularity of the coaching trade half of the inn was converted to a separate lodging house, but by 1834 trade had increased and it was reincorporated back into the Eagle Hotel.

In 1858, the 7th Duke of Devonshire took over the jurisdiction of the town. He was forward thinking and believed that the people of Buxton should become more responsible for themselves and their environment. To this end the duke had his agent – a Mr Wilmott – preside over annual town meetings for all tenants. These town meetings were held at the

The Eagle Hotel.

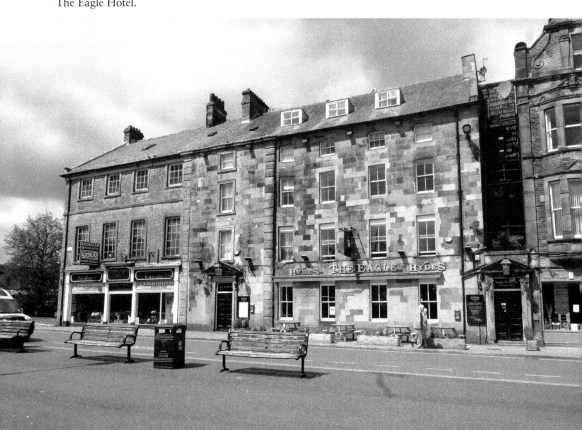

Eagle Hotel where any concerns were raised and the whole town was encouraged to solve any problems or make improvements as a co-operative.

During the Edwardian years, in the hopes of attracting a more upmarket clientele, the Eagle was renamed the Devonshire Hotel to reflect the wealth and grandeur of the dukes of Devonshire who resided at nearby Chatsworth House. This name change was not successful and the hotel reverted back to the original name of the Eagle, and has been a well-known local bar ever since.

4. The Grove Hotel, 1770

The Grove Hotel has sadly been closed since 2013, when it became financially impossible to keep it in good repair. Although the building has been kept structurally sound, no plans are in place to restore the building or convert it at this point in time.

The Grove Hotel was originally built and opened in the seventeenth century as the Grove Coffee house. It was a three-bay building fronting onto Tideswell Lane, which is now called Spring Gardens. When the coach route from London to Manchester started to pass through Buxton, bringing its associated trade, the owners of the coffee house saw a business opportunity and expanded the building and business to create a new hotel.

The Grove Hotel.

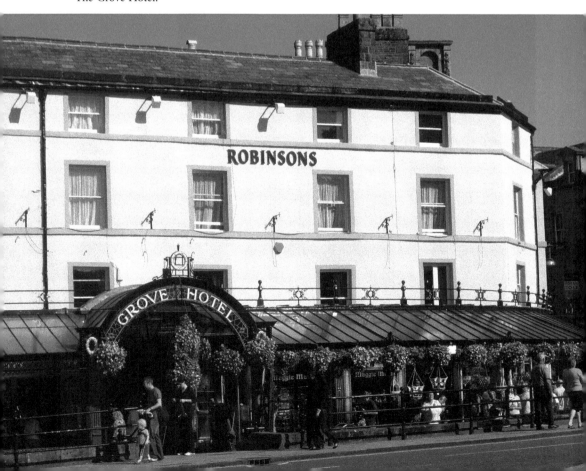

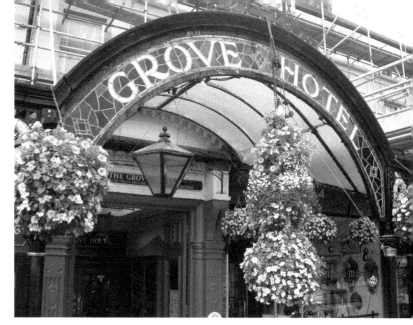

The glass and iron
entrance to the Grove.

The new venture was to be known as the Grove Hotel. More expansions occurred in the
1770s and the business continued to flourish. The lower floor was converted to a row of
shops and a covered walkway was added to the original building in 1883.

The Grove Hotel's popularity started to decline but it continued trading until flooding
and other structural problems forced it to close in 2013.

The Grove Hotel is unusual in Buxton as it is not faced in stone but has a stuccoed
white-painted front. The roof is more traditional for the town as it is clad in Welsh slate.
The beautiful and iconic glass-roofed colonnade has intricate ironwork and balustrades
and still acts as a walkway for shoppers in the town. They can browse the elegant Victorian
shopfronts, some of which retain original windows and doorways, and be reminded of
Buxton's refined Victorian past.

5. The George, 1770

In the eighteenth century Buxton was on the main London to Manchester coach route
and, when it was built in around 1770 , the George Hotel faced onto the original
Manchester Road. Unfortunately, with the diversion of this road in 1780, the George
lost out in trade to the Grove Hotel as it was the Grove that now fronted onto the main
through route.

However, the George still did a good business as a base for commuters. In the 1850s, well
before Buxton had its own direct railway service, a horse-drawn coach known as 'The Peak
Guide' offered rail travellers a return journey to the closest railway station. The carriage
departed daily from the George Hotel, went through Ashford and Bakewell and arrived
at Rowsley station to connect with trains to London and Derby. It proved a very popular
sideline for many years until Buxton got its own railway station in 1867.

Despite being described by John Leach in The Book of Buxton as having 'never achieved
anything of particular note', this Grade II-listed building was a popular pub and venue
before it closed in need of refurbishment in 2007. This Georgian hotel is simple in style,
stone clad with multiple sash windows. There was a later addition of dormer windows.

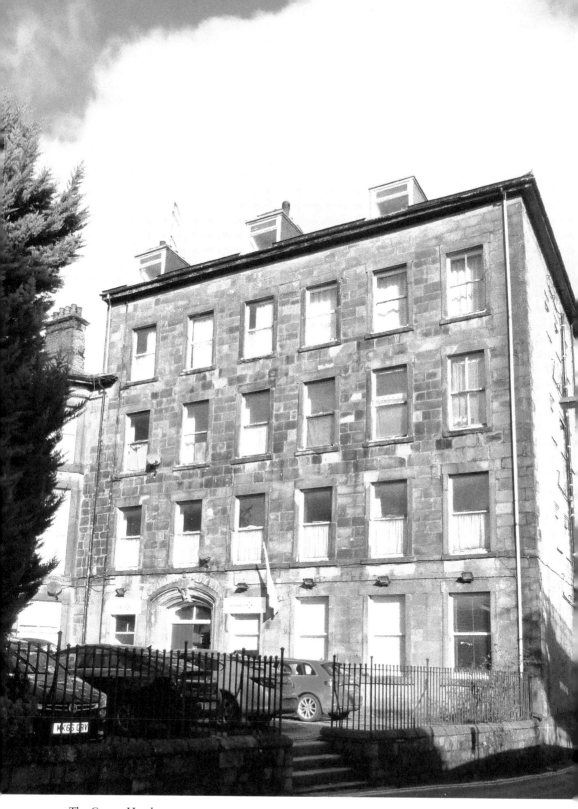

The George Hotel.

The George has since been purchased by the developers of the Crescent and is presently being used as their headquarters while the Crescent project is underway. Plans are in place to reopen the George as a hotel again when the new development is finished and it can then be restored to best display its simple charm.

6. The Crescent, 1780

As Buxton's only Grade I-listed building it is good to know that this magnificent neoclassical-style building, with its twenty-nine symmetrical windows and giant fluted Roman Doric columns, will soon be open once more as a luxury accommodation and spa complex. This will restore to the building the grandeur and importance that it enjoyed when it first opened in 1789.

The 5th Duke of Devonshire, William Cavendish, commissioned architect John Carr of York to build the Crescent in 1780. It was to be the centrepiece of the duke's plan for Buxton to become a fashionable spa town to rival the city of Bath. Indeed, the Royal Institute of British Architects says the Crescent in Buxton is 'much more richly decorated and altogether more complex' than the Royal Crescent in Bath. The dining room of the Crescent has also been described as 'one of the finest examples of Adam style decoration in the country'. It boasts ornate plasterwork wall plaques, coved ceiling decorations, marble fireplaces and spectacular overmantels.

At that point in the eighteenth century Buxton was merely a hamlet of around 200 people, but as 'taking the waters' had become a fashionable pastime for the elite, the duke

The Crescent.

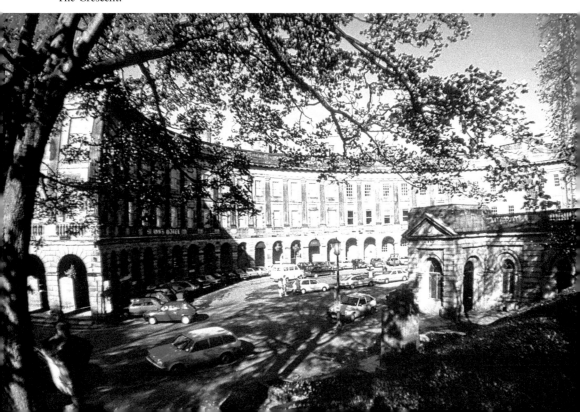

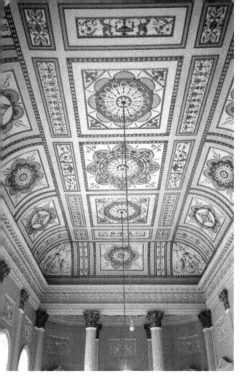

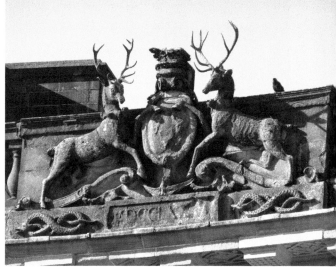

Above: The ducal stags on top of The Crescent. The antlers are supplied from the herd at Chatsworth estate.

Left: The Assembly Room ceiling, The Crescent.

decided to use the thermal spring that lay within his lands to impress his peers by creating a spa town of his own.

The geological layers in Buxton allow a thermal spring to emerge at a constant temperature of 27.5 degrees Celsius from a mile within the earth. The mineral water is already 5,000 years old as it emerges.

The duke used the profits from his copper mine in Ecton, Staffordshire, to fund the project for the Crescent and the town. It cost him £41,500 to build, which would have been around £55,000,000 today. Curiously, it is an almost identical figure that is being spent by the current developers to restore the Crescent to its former glory.

Although the building of the Crescent has left an architectural legacy, geological and archaeological damage was done in the process. The site chosen required the culverting of the River Wye under the building site, the suppression of at least one of the natural springs that, ironically, the duke was hoping to promote, and the project probably destroyed the last surviving remains of the Roman baths. The subsequent landscaping of St Ann's Cliff in front of the Crescent in 1792 provided little compensation for the loss of the old gardens that, despite having been laid out hundreds of years before in front of the Old Hall, were destroyed during the build.

The Crescent consisted of two hotels, St Ann's Hotel and the Crescent Hotel, also lodging houses, public assembly rooms for card playing, dining and dancing and an arcade of shops. The centre of the Crescent was constructed as a major town house for William Cavendish, but by 1804 it had been little used by him and was converted to become a third hotel, the Centre hotel. Within thirty years of its completion, the central hotel and most of the smaller lodging houses had been absorbed into the two flanking hotels to create a pair of grand accommodation complexes.

The Crescent Hotel continued to trade until 1935. Its heyday was around the turn of the twentieth century when its advertising campaigns proclaimed that it had 'enjoyed the patronage of Her Majesty Queen Victoria' who had enjoyed it's 'electric passenger elevator' and the hotel's 'direct access by covered colonnade to Buxton Mineral water, spa baths, Pavilion, fine

ornamental gardens and Opera House'. After it was closed to paying guests, the Crescent Hotel became a clinic annexed to the Devonshire Royal Hospital. In the 1970s it was acquired by the Derbyshire County Council and used as the town's library until it was finally vacated in 1991.

The St Ann's Hotel continued in use as a private hotel until 1989, but at the time of its closure the building was in a very poor state of repair. This was exacerbated by severe gales in 1990, which caused considerable damage to the roof.

There was a protracted campaign to save the Crescent, initiated by the newly formed Buxton Group. It was vital to get direct action by the Department of National Heritage (now called the Department for Digital, Culture, Media and Sport) to ensure that the building remained sound. This resulted in grants totalling £1.5 million to enable repair works to be carried out during the years of 1994–96. Many attempts were made to try and find a suitable developer for the building and this finally produced results.

The Trevor Osborne property group in association with Danubius Hotels came up with a scheme to create a hotel occupying the majority of the Crescent. It incorporates a natural mineral water spa in the adjoining Natural Baths building and the development of the Pump Room to allow visitors to 'take the waters' once again. This ambitious project will restore the Crescent to its position of the 'centrepiece of Buxton' as envisaged by the 5th Duke of Devonshire and is on schedule to open in 2019.

7. The Devonshire Hospital (The Great Stables), 1785

The hospital is a Grade II-listed building and more popularly known as the Devonshire Dome. The origin of the building, however, was not the care of patients but that of horses.

The building of the Crescent by William Cavendish was to attract paying guests, which meant that consideration had to be given to the horses and grooms that came with the visitors. With their accommodation in mind the duke commissioned architect John Carr

The Devonshire Hospital, formerly the Great Stables, now home of the University of Derby.

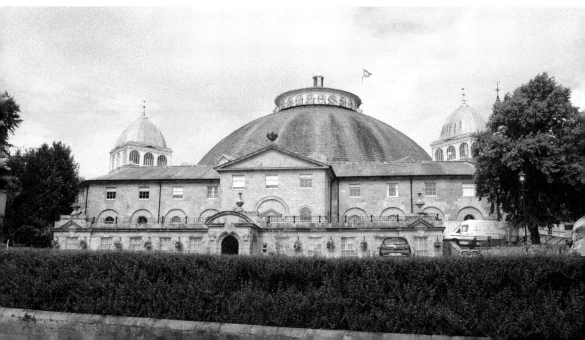

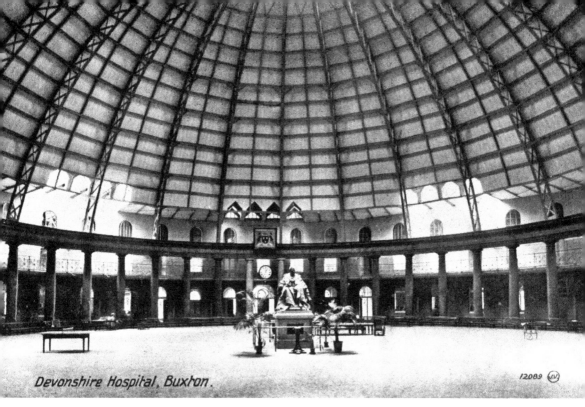

Devonshire Hospital, Buxton.

12089 (JV)

Postcard showing the interior of the Devonshire Hospital with a cast of the statue of the 6th Duke of Devonshire that is located in Eastbourne.

to design a stable block and exercise yard with lodging on the hill above the Crescent. The resulting octagonal building built around an open exercise yard would stable 120 horses and was the blueprint for the Royal Devonshire Hospital as it now stands.

Through the charitable activities of the Buxton Baths Charity, the Buxton waters and baths had been made available to the 'sick poor'. Using subscriptions and donations, the charity was able to fund up to three weeks' treatment for those sent on the recommendation of clergy. They came, in many cases, from 'Cottonopolis', a wide area of industrial towns to the north and west. The influx of the charity cases led to the town planners feeling under pressure to provide separate baths for the poor and also suitable accommodation to be found for them.

In 1859, the 6th Duke of Devonshire granted the use of part of the stables to the charity, which then changed its name to the Buxton Baths and Devonshire Hospital Charity. This act of generosity coincided with the arrival of the railway to Buxton when the need for stabling had greatly diminished. The Buxton Cure was becoming so popular and successful with the increasing numbers of workers from the cotton industries that the trustees of the charity eventually persuaded the 7th Duke to pass over the remainder of the Great Stables for their use. They planned to double the number of patients who could be treated to 300.

Robert Rippon Duke, the local (and largely self-taught) architect, came up with an ambitious and imaginative scheme to redesign the whole building. His plan was to enclose the whole of the central courtyard, previously used to exercise the horses, with a huge slate-clad steel dome some 42 metres across and supported by twenty-two steel arms. However, following the Tay Bridge disaster in 1879, Robert Duke was concerned about the number

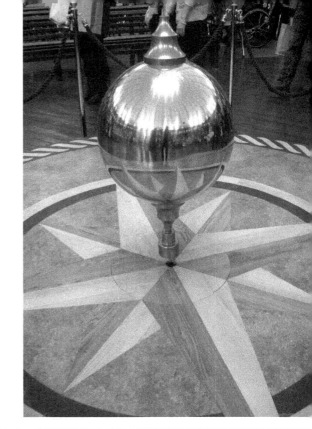

Right: Foucault's pendulum suspended from the dome.

Below: View of the dome showing the pendulum.

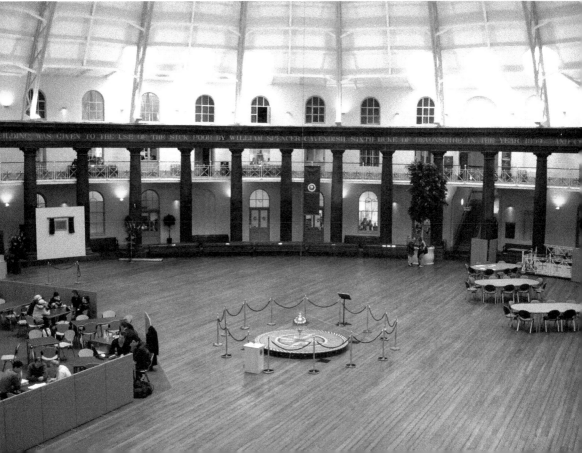

The Foucault Pendulum

What is it?
You are looking at a special kind of pendulum invented by nineteenth century French physicist Jean Bernard Léon Foucault (1819 - 1868) to demonstrate how the Earth rotates about its axis. It was first shown to the public in the Meridian Room of the Paris Observatory in 1851. Later, at The Pantheon in Paris, Foucault used a pendulum with a longer wire to show a rate of oscillation over 24 hours perfectly in line with his predictions.

What does a pendulum do?
A pendulum hangs from a fixed point and, when pulled back and released, is free to swing down by force of **gravity** and then out and up because of its **inertia** (where bodies in motion stay in motion and bodies in rest remain at rest unless acted on by an outside force). The weight at the end of the wire is called a **bob**. Pendulums measure acceleration due to gravity and keep accurate time.

What's special about the Foucault Pendulum?
A Foucault Pendulum can demonstrate the rotation of the Earth from any point on its surface, but the movements differ depending upon where on Earth you are! Once in motion, the Foucault Pendulum seems to change its path during the day. Actually it is the floor beneath that moves, twisted in space by the daily rotation of the Earth.

What it shows
The two kinds of motion about the Earth's axis are **twist** and **travel**. **Twist** describes the motion of a plane (a flat surface) around a perpendicular axis. At the North or South Pole the Earth would twist a full 360° circle in 24 hours. At Buxton's latitude in 24 hours the floor turns about 288°. **Travel** is the motion of a plane in a circle around an axis parallel to the plane. To better understand this, imagine the Pendulum at the Equator. The building floor would not twist at all but the building would travel eastward on the Earth's axis.

Why is all this important?
People once believed the Earth was flat and that stars and planets travelled through the night sky around the Earth. In 1543 Copernicus suggested the Earth rotates daily on its axis as part of a general theory that the Earth actually revolves annually around the Sun. Scientists accepted this idea but it took nearly three centuries to find an experiment that could be performed on Earth to demonstrate it to the wider public. Practically, if the Earth didn't frequently spin, there would be a steady flow of cool air from Pole to Equator. Cool air near the surface would warm, and the air would gradually rise and flow back towards the Pole, dropping its water content as it again cooled. This would tend to produce constant rain near the Equator and deserts in the northern and southern parts of the world - the rotation of the Earth helps break up this north-south cycle by introducing an east (or west) deflection.

What forces act on the Pendulum?
The Pendulum's **inertia** makes it swing straight out. **Gravity** pulls it straight back (or rather 'down' - the force of the wire makes it move in an arc rather than straight down). **Air resistance** makes the Pendulum swing in shorter arcs. In this demonstration, an electromagnet booster counteracts the air resistance. Since it is tied to the building, the Foucault Pendulum will travel laterally as the building moves laterally but, because of the way it is suspended it will not twist around if the building twists around. Air resistance would normally stop the Pendulum after a few hours.

The pendulum experts
This Foucault Pendulum has been made by Smith of Derby, who have manufactured high quality clocks since 1856, including the clock in the Devonshire Hospital's clocktower (installed in 1883). The bob is of polished stainless steel, 470mm in diameter and weighs 75 kilos (165 pounds). It is suspended from the Dome by a 28.5 metre cable.

Detail of the pendulum.

of supports in the dome and the quality of workmanship in the construction process. He insisted that all rivet holes were redrilled and aligned properly and the number of supports were increased, greatly extending the length of time to complete the project. Until recently this incredible engineered structure was the largest unsupported dome in the world.

The Victorian clock tower was added to the Georgian building in 1882 and while each are to be admired in their own right, the two styles fail to complement each other. Further developments ensued, with the addition of surgical wards and more spa baths, both of which were used by wounded veterans during the First World War. In recognition of the hospital's valuable work, George V granted it a 'Royal' title in 1934 and the name changed to the Devonshire Royal Hospital.

Natural hydropathic treatments became increasingly less popular and the hospital closed its doors to patients in 2000, the last of the eight hydropathic hospitals in the country to close.

The building was sold and in 2003 the University of Derby opened the building as its Buxton Campus and now accommodates over 2,000 students.

The Devonshire Dome is also open as a commercial venue and visitor attraction with cafés, restaurants and shops. The original spa treatment rooms of the hospital are now being used as a commercial spa and training centre for therapists. The dome also houses a Foucault pendulum. Named after the French physicist who first used the pendulum to demonstrate the rotation of the earth, the giant pendulum is one of a number displayed in universities and science museums.

Speaking of the Devonshire Royal Hospital when he officially opened the new campus in 2006, Prince Charles said, 'As someone who is extremely interested in heritage-led projects. This is a wonderful example of what can be achieved. Projects which aim to bring buildings back to life present a big challenge, but by God, it's worthwhile in the end.' It is reassuring to know that this fine Buxton building is no longer to be considered 'at risk'.

8. The Cheshire Cheese, High Street, 1787

Traditionally the sign of the Cheshire Cheese outside an inn denotes that a warm fire, hearty meal and tankard of ale lie inside. This is the case in Buxton. The Cheshire Cheese on High Street offers good local ales, fine food and roaring fires.

Although the origins of the building are not known, the Cheshire Cheese was certainly offering food and lodging as early as the eighteenth century. It was then that the actor S. W. Ryley, while playing at Buxton, recollected, perhaps in his book The Itinerant; or Memoirs of An Actor, having enjoyed 'a fine trout supper' there.

For most of the nineteenth century the inn was owned by the local landowners, the Mycock family. It was Solomon Mycock who allowed the folly 'Solomon's Temple' to be built on his land above Buxton.

Like most hostelries in Buxton at that time, the Cheshire Cheese traded as a coaching inn for the Manchester to London service; however, in 1835 it was listed as a carrier's inn. This implies that its trade came more from the working classes than those hostelries closer to the Crescent.

The inn is a single-storey, stone building. The long slate roof has stone chimney stacks and some very high chimney pots. The rounded, black and white painted timber bay front has similar angular bays to each side and all are topped with wooden balustrades. The façade is attractive and inviting and the business continues to thrive.

The Cheshire Cheese Hotel.

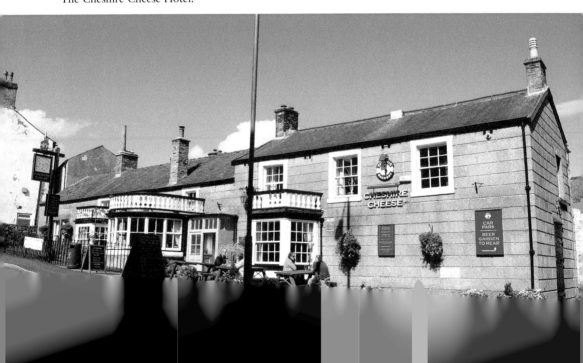

9. Bath House, Macclesfield Road, 1793

During the 1780s, while the 5th Duke was building the Crescent and redeveloping the whole of Buxton as a spa town, it was noted, with not a little excitement, that 'further springs had been discovered that were not under the control of the Dukes of Devonshire'.

Eager to exploit this fact, a Dr Norton of Macclesfield decided to use this find for medicinal good. He purchased the land containing the springs and went on to develop the site.

In 1793 he built a bathhouse to enclose the springs. The bathhouse measured 30 feet by 12 feet and with his success at hydropathic remedies, by 1797 the doctor had ordered that the bathhouse be enlarged and divided to allow the treatment of male and female patients separately.

Unlike those in the town centre, the waters on the site issued at a temperature of just 17.7 degrees Celsius. As the water was cool, Dr Norton used his establishment for tonic or cold plunging – bathing remedies for many years.

There were attempts to raise the temperature of the water, either at source or by installing radiators in the pool, but these all proved unsuccessful and the water remained cool. At one time the boys from Buxton College had swimming lessons there, which were naturally not popular.

The remains of the tonic baths were still there in the 1950s, but they were eventually demolished and a private house built on the site. The house that Dr Norton had built for himself adjacent to the baths is now Grade II listed.

Bath House, Macclesfield Road.

10. Hall Bank, 1793

This terrace of properties forms a link between the Elizabethan Old Hall Hotel and the Georgian buildings of the upper town. They are built on a road that has quite a steep gradient, which may have been a challenge to the architect.

The properties were believed to have been designed by John Carr, the architect who worked closely with the Duke of Devonshire on the conversion of Buxton to a spa town. The houses were built in pairs between 1793 and 1798. Each pair have slightly different design details, but the basic Georgian style with stone construction and slate roofs is the dominating feature.

Although the houses were built at different times it was usual for the same local builders to be employed by the architects. This ensured consistency in style and also brought more prosperity to the town.

The bay windows were added in the late nineteenth century. Like many Georgian town houses, Hall Bank was extended and converted to lodging houses at this time when the arrival of the railway to Buxton also brought the arrival of increased trade.

The bottom house in the row is now missing as it was demolished to provide a building site for a hotel, originally the Burlington Hotel, it later became the Savoy.

Nos 2 and 3 Hall Bank.

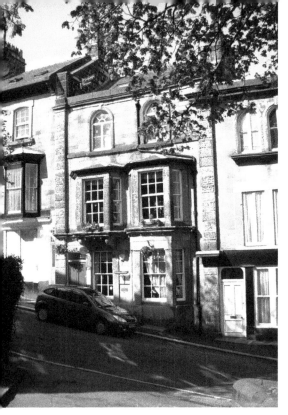

Above left: Nos 4 and 5 Hall Bank.

Above right: Nos 6 and 7 Hall Bank.

Below: No. 8 Hall Bank.

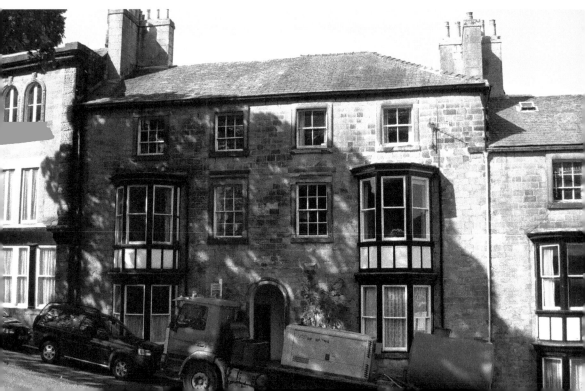

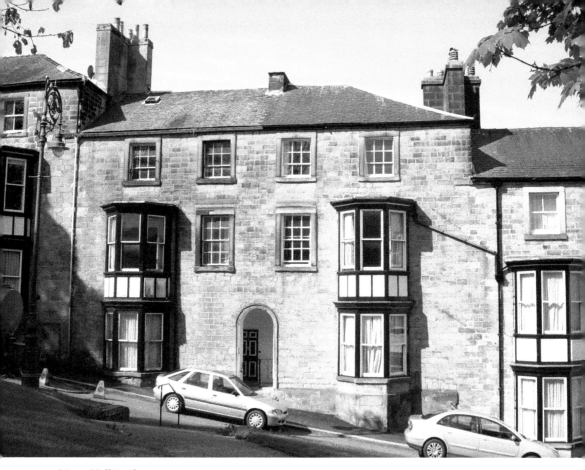

No. 9 Hall Bank.

11. The White Lion, Spring Gardens, 1798

This fine public house, now sadly closed, was originally built as a carrier's inn. The original address would have been on Tideswell Lane until this later became known as Spring Gardens. It is a compact stone building, three storeys high with darker stone decorative edges and a slate roof.

Carrier's inns were common during the eighteenth and nineteenth centuries. Traders would set themselves up in the yards of inns and use this as a base for transporting goods and materials to surrounding areas. At least five carriers a week used The White Lion, serving places such as Macclesfield, Leek, Manchester, Chesterfield and Sheffield.

Although now lined with modern shopfronts, Spring Gardens still has a reminder of its history. Alleyways still exist between the shops that lead to the yards behind. One of these 'gennels' leads to the rear yard of The White Lion. Here the traders and their horses would have gained access to their trading sites. It is still cobbled with the original small, square gritstone setts.

The White Lion ceased trading in 2011, but like many of the buildings in Buxton, plans are being made to breathe new life into it. One such plan is to create within the pub and its yard an 'artisan quarter' of small retail units for independent Peak District traders and producers. If this were to go ahead it would reflect nicely on the pub's origin as a carrier's inn.

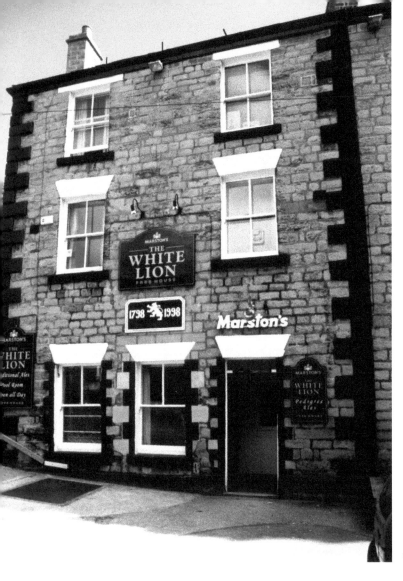

The White Lion inn.

12. Longden Court, Spring Gardens, 1799

This Grade II-listed building was built at the end of the eighteenth century in what was then Tideswell Lane. It is a plain design in stone and has all original cobbles to the rear.

It was built as either separate workshops or a factory. Evidence of this can be seen in the external stone stairways. The purpose of these staircases was to allow easy access to the workshops on the upper floor when carts were being loaded or unloaded of goods.

By the late nineteenth century Longden Court had been converted to cottages. These were not well maintained and became squalid. One of the last people to live in the cottages before they were condemned and subsequently converted in 1933 was a Mrs Vipulis (née Varey). Mrs Vipulis' daughter recalls her mother's memories of the property and one of the more graphic was the need for the Varey family to share the only earth toilet with six other families. Described as 'dark, cold and horrid' this was little more than a tiny, purpose-built shed set on a narrow path behind the building.

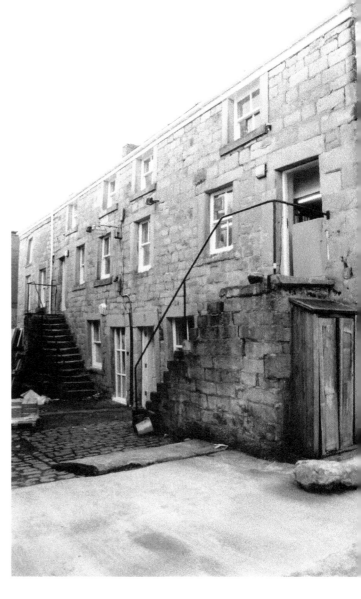

Longden Court, Spring Gardens.

Since being converted Longden Court is now being used by shops, offices and small businesses on its lower floor. The upper floor is residential.

13. Buxton House, Terrace Road

This Georgian property was built in the late eigteenth century as a town house. From 1881 it was known as the Buxton House Hydropathic Establishment and was owned by a Dr Samuel Hyde. He opened and ran the business with much success, despite Terrace Road being nowhere near the site of one of Buxton's natural springs.

The idea of hydropathy was developed in Germany in the 1830s and was based on the belief that any water taken internally or used externally could cure all manner of ills. This meant that the water used for treatments did not rely solely on mineral or spring waters. Hydropathy, therefore, had one big advantage to entrepreneurs in that

Buxton House, Terrace Road.

unlike 'taking the cure', mineral water did not have to be used. The premises of such establishments did not have to be situated near a water source and water could be brought in from anywhere.

The Buxton House Hydropathic Establishment had a wonderful interior. There are written descriptions of a magnificent open staircase, upstairs glass conservatory and a 'jewel-like glass screen' in the hallway. The basement was used to house the baths for the hydrotherapy treatments. The building next door (now solicitors' offices) was originally used as stabling for visitors' horses and accommodation for the grooms.

The building has a lovely Georgian columned portico around its central door and the arched dormer window complements the window in the stairwell. It has a fine double-bayed front. This was altered after the closure of the hydro to create the two Edwardian-style shopfronts that are still in use today.

14. St John's Church, 1811

The parish church of St John the Baptist was the last gift to Buxton from the 5th Duke of Devonshire. It was necessary to replace the old church on Bath Road that had increasingly fallen into disrepair. The old church on Bath Road was later restored and rededicated to become St Anne's.

The duke had the new church designed by architect John White and it was finished in 1811, the same year the 5th Duke died. The church was dedicated the following year to St John the Baptist.

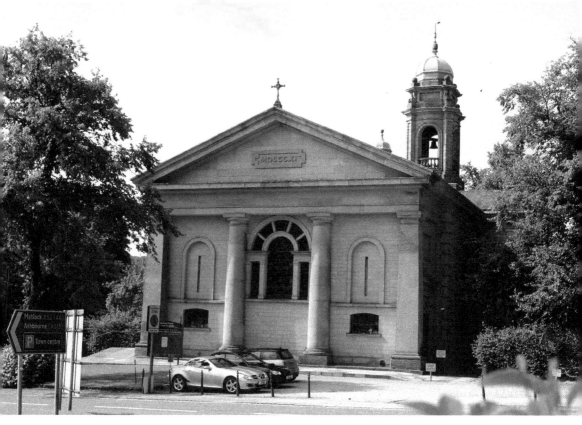

Above: St John's Church.

Below: St John's Church floodlit.

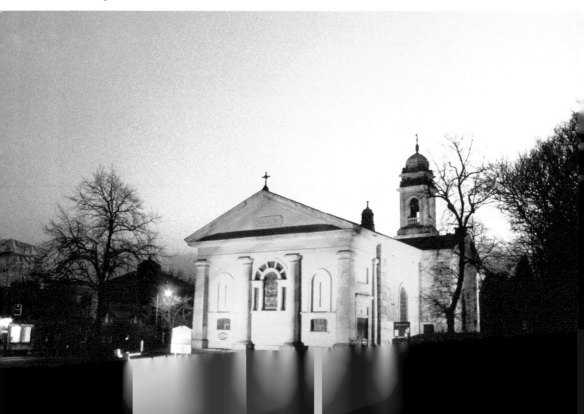

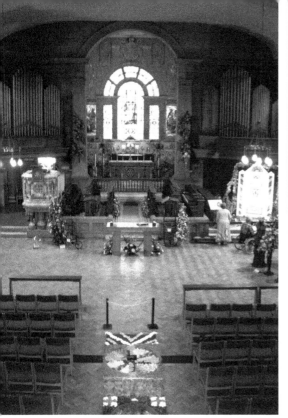 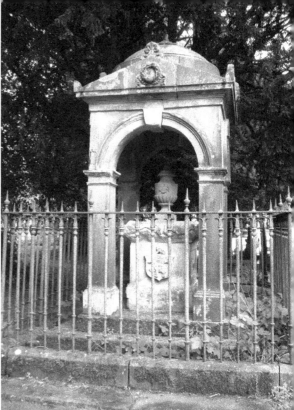

Above left: Interior of St John's Church during the annual flower festival.

Above right: Tomb of Phillip Heathcote, St John's churchyard.

The church is a good example of the neoclassical style of architecture. It has plain undecorated Tuscan columns, and the simplicity of its appearance is as appealing now as it was when the church was new. The classic Regency style led to it being often photographed in the Victorian era when this Grade II-listed church was considered very fashionable.

Unusually, the entrance was originally at the east end. It had two entrance doors at either side of the altar. In 1897 the east entrance porticos were closed in when the nave was remodelled by the architect Sir Arthur Blomfield. The entrance door was then moved to the traditional west end.

Inside the church, the absence of pillars gives a feeling of space. There is an original Georgian stained-glass window and also five more that were designed by the renowned Victorian stained-glass window artist Charles Eamer Kempe.

Still a place of worship and quiet contemplation, the church also hosts most of the concerts put on by the Buxton Musical Society. There is a Victorian William Hill organ, and the acoustics in St John the Baptist make it a good venue for musical events.

15. The Square, 1803

The uniformity of this building and its open colonnade are in perfect keeping with the buildings surrounding it. The property is Grade II listed and has a simple, clean design to its stone walls and slate roof.

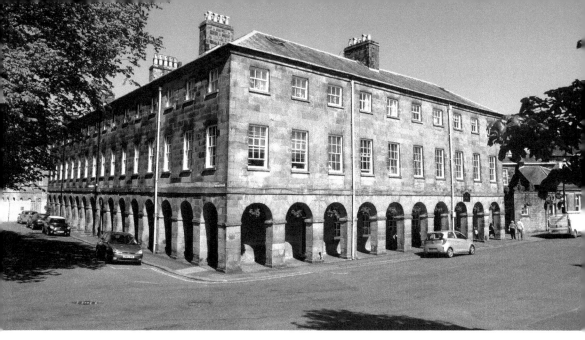

The Square.

It was built as a series of six town houses between 1803 and 1806 and the architect was John White & Son. Each town house was all but identical inside and out. All the properties had the same layout of entrance hall with a reception room to either side, kitchen and dining room to the rear and sleeping accommodation upstairs.

Early residents included Robert Rippon Duke, the renowned Victorian architect and Dr J. Robertson, who was both a noted authority on water treatments and chairman of the trustees of the Devonshire Hospital.

The 6th Duke of Devonshire's agent, Phillip Heacock, also lived in one of the grand houses in the square. The duke owned most of the newly flourishing town of Buxton and this made his agent a very powerful and wealthy man too. It was Heacock's responsibility to vet any building proposals for the duke. Although Heacock would always say 'I'll take your design to the duke', it was an in-joke among his peers that any plan the agent didn't care for would go straight onto the fire. 'Take it to the duke' soon became a euphemism for 'throw away' within his circle of friends. The tombstone of Phillip Heacock is in the churchyard of St John the Baptist and is a listed monument.

Nowadays, the square houses many commercial buildings and part of No. 6 is now a fashionable café and guesthouse. The residents of the guesthouse can still enjoy the wonderful view over the Pavilion Gardens to the Opera House with the Devonshire Dome in the background. One online review from a guest at No. 6 described their room as being like 'having their own private mansion'. It would be interesting to observe their reaction if they had stayed in the original unaltered town house as built for the elite of Georgian Buxton.

16. The Old Sun Inn, High Street

This traditional white-painted pub has been here since the seventeenth century and is thought to be one of the oldest buildings in Buxton. It was built to serve as a coaching inn and this part of the history of the Old Sun Inn is made apparent by the arched passageway inscribed

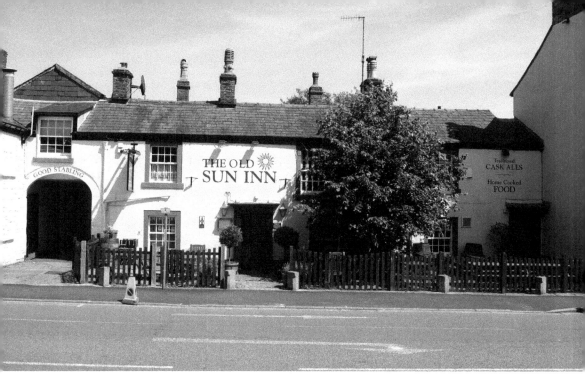

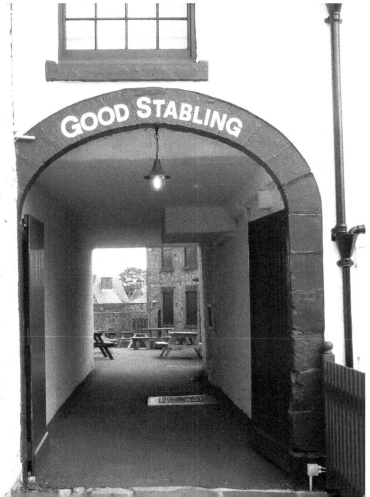

Above: The Old Sun Inn.

Left: Entrance to the yard of the Old Sun Inn showing its coaching ancestry.

with 'Good Stabling' that leads through to the backyard. The property is set back from the road slightly to have allowed coaches to pull up outside while their passengers alighted.

Inside, its layout had been little altered. It has stone floors, oak timbers and wooden panelling decorating the maze of cosy alcoves that radiate out from the central bar.
From the early nineteenth century the carrier service brought trade to many of Buxton's inns and the old Sun was no exception. The carriers used a warehouse close to the inn and brought it much trade.

It was known for a short time in the 1830s as the Rising Sun, but this name was not popular and so it soon reverted back to the one it has today.

17. The Swan Inn, High Street, 1811

This public house lies across the road from the Old Sun Inn. The three-storey building is faced with stone and has casement windows. Like much of Buxton in the early nineteenth century, it was built in a simple Regency town house style.

When originally built it was known as the Shoulder of Mutton. The first mention of this name was in 1811. The catalyst for the name change happened around 1850. According to witnesses at the time, the landlord unjustly accused a young soldier of not paying for his drink. Despite protests from the tavern customers and protestations of his innocence from the soldier, he was taken out and tied to a tree by the cemetery. The landlord then publicly flogged the young man. The regulars, who were appalled by this unfair and brutal act, boycotted the inn. Some years later the landlord eventually left and the name was changed by the new innkeeper to the Swan. This was an attempt to dissociate the pub from the flogging incident and the idea worked as the Swan still enjoys good custom today.

The Swan Inn.

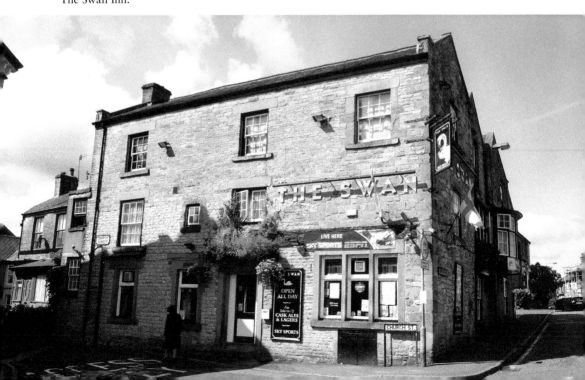

18. St Peter's Church, Fairfield, 1839

St Peter's Church is on the edge of Fairfield common to the north of Buxton town. The first chapel was built here in the Middle Ages when it was decided by the clergy that it was too far for the locals to go to the nearest church without 'serious risks to their person' in winter months. The nearest church was many miles away in Hope.

During the persecutions of Queen Mary in the mid-sixteenth century the chapel was closed and the congregation were forced to hold services and burials a mile and a half away in a barn and hope they would not be discovered. The chapel had its first rebuild when it reopened at the end of that century. The renovated church served the local community for many years until it gradually fell into disrepair.

In 1772 John Wesley visited Buxton and he preached a sermon from the limestone mound that lies just to the west of the church tower.

The present church was completely restored in 1839. It was commissioned and designed by Joseph Swann, the village schoolmaster. Swann felt the church was in too bad a state of repair to be in constant use and he was said to have been 'of remarkable character and the driving force behind the new church'. A memorial scroll to him and his descendants can be seen inside St Peter's.

Later additions were made to the church, with transepts, chancels and a vestry all being added at the turn of the twentieth century. It was while these alterations were taking place that the painting of a cherub was found on an enclosed portion of the ceiling. Believed to be

St Peter's Church, Fairfield.

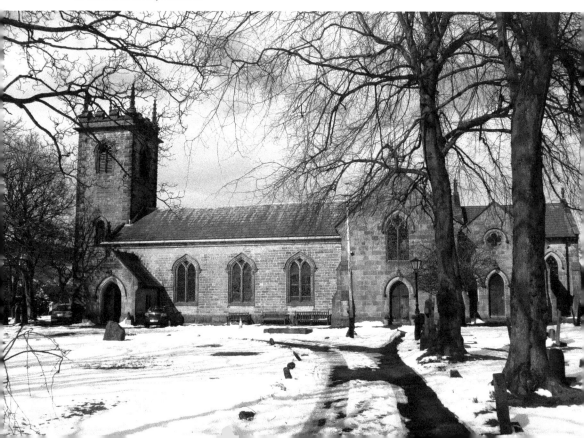

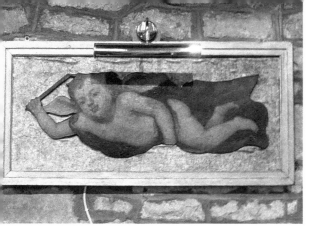 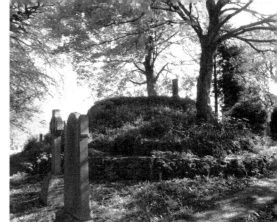

Above left: Medieval cherub wall painting.

Above right: Mound where John Wesley preached.

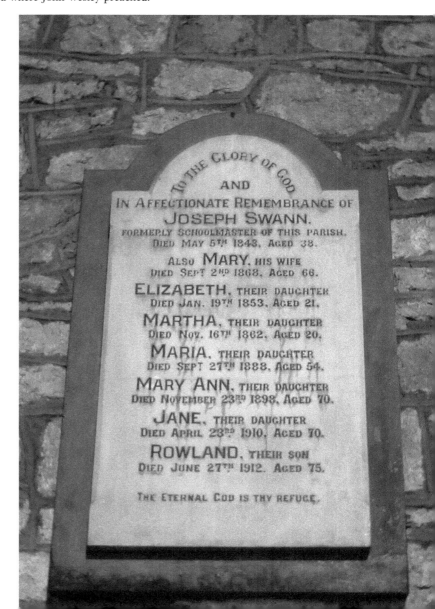

Memorial scroll to
Joseph Swann.

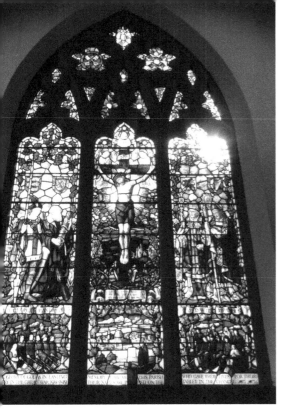

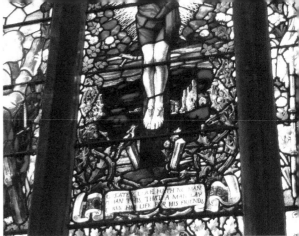

Above: Detail of window – can you spot the biplane?

Left: Memorial window, St Peter's Church.

part of a medieval Madonna scene, and likely to have been obscured during the time that St Peter's was out of use during the persecutions of Mary. Now, fortunately, it is open to view within the church.

The east window is dedicated to those who lost their lives in the First World War and was unveiled in 1919. It is unusual as it depicts the crucified figure of Christ against the backdrop of a battlefield. The battle scene includes a bi-plane and this is the first memorial window to show aircraft.

The external architecture is typically Victorian. It is simple in style and has a small castellated tower. The tower, however, appears slightly dwarfed by the transept. St Peter's appears unremarkable but it has a host of hidden gems for those willing to explore its fascinating past.

19. Solomon's Temple, 1840

Solomon's Temple sits 1,440 feet above sea level and commands impressive views of the surrounding Peak District countryside. The structure itself is only 20 feet high but is certainly impressive enough to have the title 'temple'.

Also known as Grin Low Tower, Solomon's Temple was a folly built under instructions from the 6th Duke of Devonshire. The duke wanted to provide work for Buxton town's unemployed. Land was leased from Solomon Mycock, a local innkeeper, farmer and landowner. The site chosen was on an ancient burial mound above the town. It was completed in the 1840s.

Eventually the tower fell into disrepair and by 1894 only a few stones remained. The townspeople of Buxton wanted to rebuild the tower and appealed to the 7th Duke of Devonshire for funds. The duke agreed the plan to rebuild, but only if the town could pay

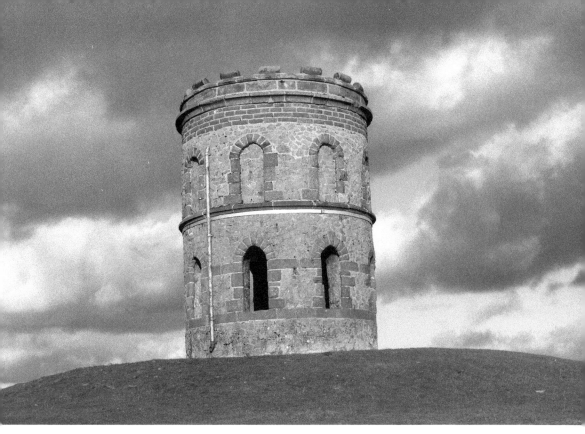

Solomon's Temple.

for much of it itself. The Buxton people undertook a fundraiser and £50 was raised. The duke put in £25 and the tower was reconstructed in just three months. It was during this rebuild that the site was excavated and archaeological remains were found. These were from the Bronze Age 'Beaker People' and also Roman artefacts. The excavated finds are on display in Buxton Museum. In 1896 Solomon's Tower was reopened by Victor Cavendish MP.

The rebuilt temple started to deteriorate again only too soon, and by the 1980s it had lost its stained-glass windows, oak door and flagpole. It became a fenced off, unsafe ruin.

True to the spirit of Buxton, the town again petitioned for repair and took it upon themselves to raise money for the cause. Celebrity Tim Brooke-Taylor, a son of Buxton, was a major contributor to the fundraising campaign and finally enough was raised to restore Solomon's Temple in the late 1990s.

The tower now sits above Grin low Woods and acts as the focus for several popular walks from the town. The interior contains a stone staircase to the top and a viewpoint. It is perhaps a relief for walkers who have already ascended Grin Hill, that Solomon's Tower is just 20 feet tall.

2c. Lime House, Macclesfield Old Road, 1841

Lime burning was commonplace in the Buxton areas of Grin Low and Burbage during the eighteenth and nineteenth centuries and the labourers on these sites were very poorly paid. The rudimentary dwellings called lime houses became an improvised way to save money on rented accommodation for them and their families.

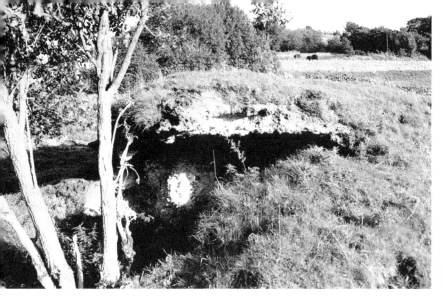

Remains of a lime house.

During the early Victorian years one well-to-do visitor to a lime burning site remarked, 'I looked in vain for the habitations of the labourers and their families but could see not one cottage. It was shortly after that I realised that they resided underground, like so many moles.'

Lime houses were created when the labourers excavated the spoil heaps of lime ash that had hardened due to carbonisation. They would dig out a cave that would become a dwelling of three or four rooms. A chimney hole would then be cut out of the top. Some dwellings used the chimney hole to let out smoke and also let in light, while others were more elaborate and had the addition of a chimney stack and simple cut-out windows to provide extra light. Although basic these lime houses could be warm and dry.

As late as 1857 there were still three or four lime houses used as dwellings on Grin Low. It wasn't until the end of the century that the lime houses were finally abandoned. They were no longer needed as the Duke of Devonshire had provided the inhabitants with new cottages in Burbage and by Poole's Cavern.

Although the Buxton lime houses ceased to be used as dwellings, this was not the case in surrounding areas. Here, without the support of the duke, others were forced to continue their troglodytic existence. In the July 1863 issue of Burbage Magazine, it is recorded: 'A very sad accident occurred on Friday last at Dove Holes by the falling of a room cut out of a heap of lime ashes by which two women and two children lost their lives. We should be very thankful we have no such accident to note in Burbage where lime huts used to be all too common'.

The remains of the last lime houses have largely disappeared but a few fragments can still be recognised in Grin Low and Burbage. They are a fascinating relic of Buxton's industrial past.

21. Winster Place, Spring Gardens, 1849

A Grade II-listed building, Winster Place is built on the site of a much earlier early Buxton inn called the Angel.

When the Victorian architect Robert Rippon Duke first came to Buxton in the mid-1840s, his first accommodation was at the Angel. He moved to Buxton for health reasons.

He was prone to breathing problems and the clear air of the Peak District was a good environment for him. It is ironic that the job he had taken in Buxton was, in fact, to oversee the demolition of the Angel and the construction of another property in its place – to be known as the Royal Hotel.

With the help of his friend and colleague Samuel Worth, who was the architect for the Royal Hotel, Duke, an upcoming architect himself by this time, began the task of managing the erection of the new hotel. It had been commissioned by Andrew Brittlebank, who came from Winster, Derbyshire, and it was in reference to this that the title Winster Place was given to the building. Despite being created to be the Royal Hotel the building itself has always been known as Winster Place. The name can be plainly seen adorning an original cornerstone high up on the building.

At the time of its construction this was the largest building in Buxton after the square. It was built in a gentle curve to complement the Crescent and its decorative, palisaded arches, now used as shopfronts, are very in keeping with the classic Georgian architecture of the town.

Robert Rippon Duke proved his worth with this project, as both an architect and building manager, but he also showed himself to be a typical Victorian gentleman with a strict ethic of hard work and thrift. After the construction of the Royal Hotel began, Duke took it upon himself to sack the whole of the workforce. He then rehired only the men who were willing to 'toil without loitering, talking or smoking'. Most of the men returned to the project as they needed the work and became more efficient. Duke was a fair man, however, and increased their wages.

In 1882, extensive enlargement and refurbishment of the hotel took place. With its increased size the hotel now occupied the whole of the upper floors of the property, while the ground floor was converted into shops.

As they were in an affluent spa town, Buxton hotels liked to keep up with fashion and trends. Some 1906 advertising for the Royal Hotel boasted: 'an American lift, billiards

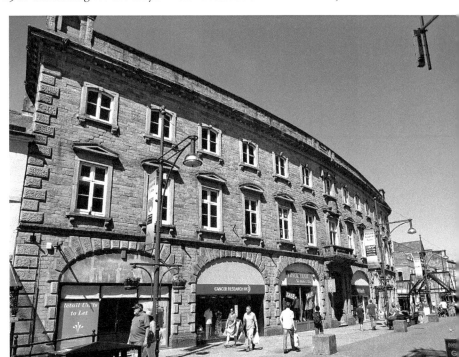

Winster Place (formerly the Royal Hotel).

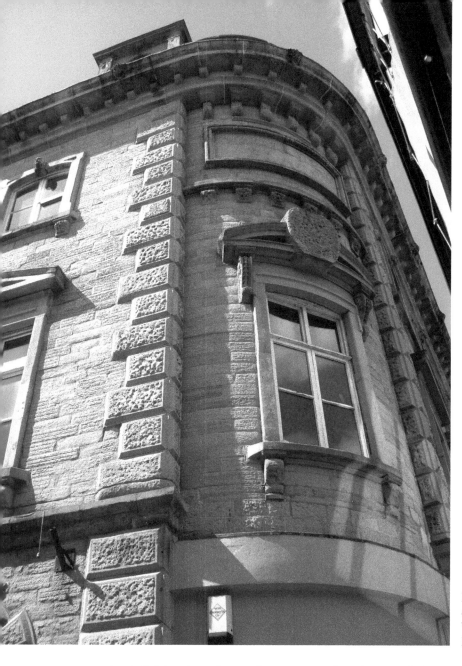

Detail of
carving on
Winster
Place.

room, electric lighting throughout and private grounds to the rear which contain a one acre lawn tennis ground.'

The hotel couldn't compete with the high number of competitors in Buxton, however, and eventually closed. Following the closure of the hotel, the building was taken over as offices for the Buxton Lime Firms Co., which subsequently was bought out by the Imperial Chemical Industries (better known as ICI). Their drawing office was located in the grand octagonal billiard room that had been a feature of the hotel.

By the 1980s the building had been vacated by ICI. The upper floors were converted into commercial units while the lower floors continued to contain shop units. Winster Place now forms an elegant part of 'The Springs' shopping complex.

22. The Quadrant (south side), Known as The Colonnade, 1851

The street known as the Quadrant is a road lined on either side by shops and commercial properties. Built as a parade of shops and still used as such today, the Grade II-listed building stands on the south side of the street as a testament to the varied architectural styles of Henry Currey, famed for work on hospitals such as St Thomas's in London.

The walkway in front of the Colonnade is covered by an eighteen-bay glass canopy. This is supported by nineteen cast-iron columns that are decorated with elegant filigree work and iron finials. Although the Edinburgh Woollen Mill now occupies a lot of the retail space and has a modern frontage, there are four units that still retain their original features. These include lovely examples of three light round-headed windows and woodwork that is both elegant and traditional.

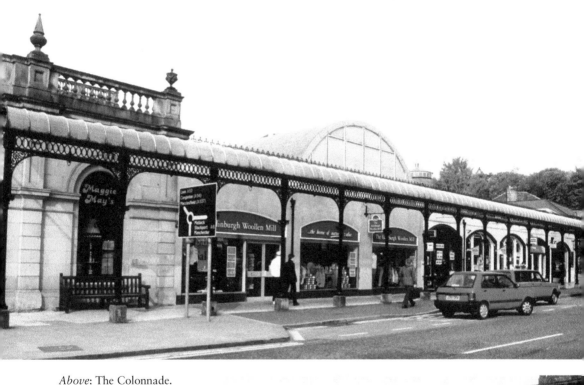

Above: The Colonnade.

Right: Postcard of the Colonnade with the Slopes and Town Hall in the background.

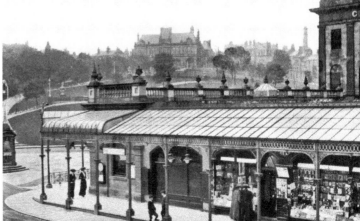

One of the first tenants to trade from the Colonnade was Thomas Woodruff. The craftsman had a large showroom and he sold his inlaid Ashford black marble pieces from it. Quarried solely in nearby Ashford-in-the-Water, Ashford black marble was particularly popular in the Victorian era, when decorative black objects were fashionable. It remained desirable until it fell out of fashion at the turn of the twentieth century. A form of grey limestone, the marble contains bitumen, which when cut and polished produces a shiny black surface. Thomas Woodruff won a prize at the Great Exhibition of 1851 for his 'Grapes Table'. Other fine examples of his work can be seen in Buxton Museum.

23. The Natural Baths, 1851

Henry Currey was the architect responsible for designing and building the Natural Baths in the 1850s. This Grade II-listed building was planned as an addition to the west side of the Crescent and is sympathetic to the Georgian style of the surrounding architecture.

The inscription 'Natural Mineral Baths' is still on the stone balustrade over the entrance despite the property being used for some time after the closure of the baths by the Buxton tourist office. The Tourist Information Centre was situated in what would have been the patients' lounge when the baths were in use.

The Natural Baths building is believed to be on the site of the Roman baths. During Roman times Buxton was at the intersection of two main military roads and the settlement was known as Aqua Arnemetiae. This meant 'spa town of the sacred groves'. Although no

The Natural Baths.

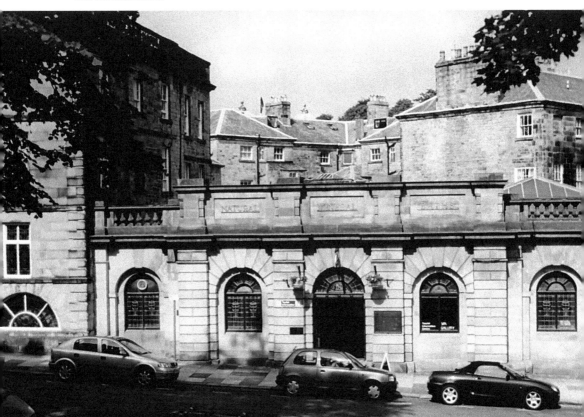

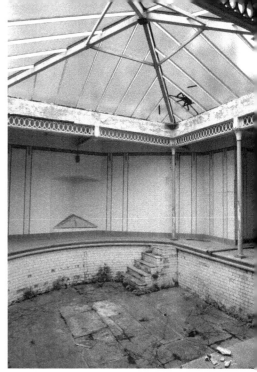

Above: Stained-glass panel in the Natural Baths.

Right: The Ladies Pool, the Natural Baths.

remains are left of the Roman building, it is likely that it consisted of hot and cold baths, dining area and accommodation. This idea and layout for spas has been used ever since. Later redevelopments of the site have obliterated any Roman remains. However Roman artefacts have been found elsewhere in the town.

The Natural Baths, built in 1851, included two ladies' private baths, two gentlemen's private baths, a public bath and a charity bath. The marble floor of each of the baths was at this time perforated, as it was believed necessary for the natural gases released by the spring waters to aerate the bath. The Natural Baths also had their own Pump Room where mineral water or chalybeate (iron-bearing water) could be taken.

Following the decline in spa treatments, the Natural Baths were used as the town swimming baths until the new pool was constructed in 1972. In 2010 the Natural Baths building was closed and will be renovated as part of the redevelopment of the Crescent as a spa complex.

24. The Thermal Baths, 1852

As the Natural Baths had extended the Crescent on the west side, so the Thermal Baths were built on the east side by Henry Currey a year later.

The Thermal Baths building is Grade II listed and replaced earlier baths built in 1818 by Charles Sylvester of Derby. It had a glass colonnade added a few years later, designed to extend the covered promenade of the Crescent. This canopy made the baths reminiscent in style to the Crystal Palace or Great Conservatory at Chatsworth.

The ability to stroll from one area of town to the other and largely under cover, was a big draw to Victorian visitors who had adopted Buxton as a holiday destination. Rather than travel to coastal resorts for the sea, they came to Buxton to take the waters. There was policy in the town at this time that reflected the manners of Victorian gentlemen. It stated

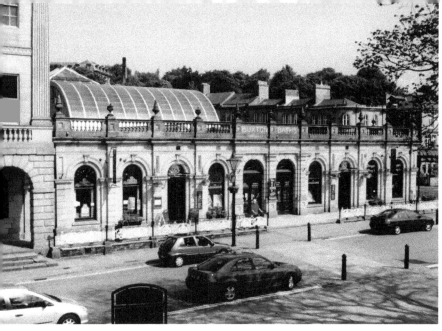

The Thermal Baths.

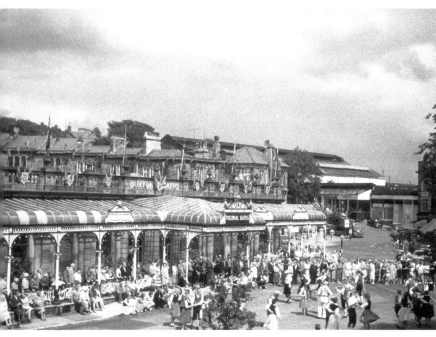

The Thermal Baths before the glass arcading was removed in the 1960s.

that 'smoking was not permitted when promenading with a lady'. There are still out door 'no smoking' signs that date back to this ruling.

The thermal spring that emits on this site had its temperature raised to around 35 degrees Celsius when the baths were in use. This made it ideal to be used by patients from the Royal Devonshire Hospital who were in recovery and would benefit from further restorative treatments.

Spa treatments went out of fashion and the baths fell into dereliction and disrepair. The Victorian glass colonnade was removed in the late 1960s.

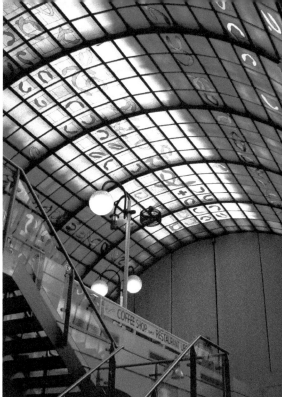

Above left: Chair in the Thermal Baths in which rheumatic patients were lowered into the plunge bath.

Above right: The new glass roof of the Thermal Baths, erected in 1986 and designed by artist Brian Clark.

Right: Original tiles in the Thermal Baths.

Above left: Original tiles in the Thermal Baths.

Above right: The remains of one of the Victorian 'No Smoking' signs.

 A major project was undertaken in the 1980s to convert the baths into a shopping arcade. This was completed with success and the Thermal Baths are now the Cavendish Arcade. It has been a sympathetic conversion and much of the original tiling from the Thermal Baths remains. Also, spa equipment and baths can be viewed through glass panels in the floor.
 In keeping with the style of the original building and its glass canopy, a barrel-vaulted stained-glass roof light has been incorporated into the arcade. Designed by Brian Clark, it gives the effect of light illuminating falling autumn leaves and has an area of 3,000 square feet.

25. The Quadrant East side, 1853

Joseph Paxton, the architect who designed nearby Chatsworth house, was also responsible for the quite widespread and radical developments that took place in Buxton during the first phase of Victorian building work that occurred during the time of the 6th and 7th dukes of Devonshire.

The Quadrant.

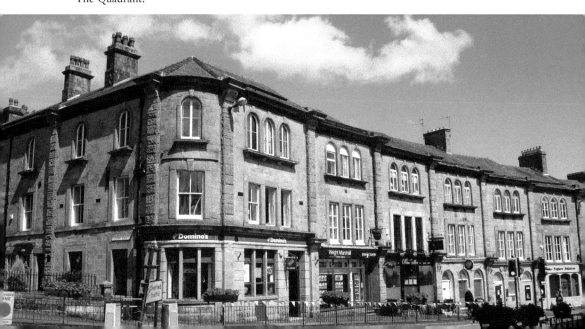

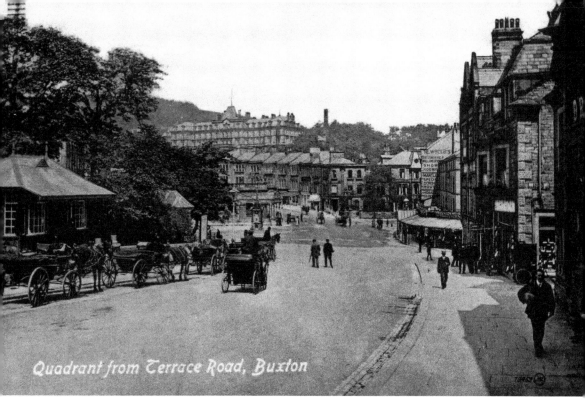

Quadrant from Terrace Road, Buxton

Postcard showing the Quadrant with the Palace Hotel behind.

The east side of the Quadrant was part of Paxton's planning for the town in 1852. The purpose of the building was to provide a link between the two important Georgian buildings: the Crescent and the Great Stables. The Quadrant was designed to be a terrace with a subtle curve. It also had a large terrace behind it and another substantial terrace to the west. His design was a complement in style to the Georgian Crescent, with arched windows and doorways, stone-faced walls and slate roof.

Robert Rippon Duke and his business partner Samuel Turner both had houses in the Quadrant, but as was quite usual in Buxton, they were rented out as accommodation. Many private homes were rented out in this way to cope with the high demand for rooms in Victorian Buxton. The position of Buxton as a resort made the need for accommodation great. It was considered a 'building phenomenon' due to the exceptionally high number of purpose-built lodging houses in the town. It was not only the middle classes who visited Buxton to enjoy its spa treatments, the working classes also visited for medicinal reasons and cheaper lodging was provided for them in less prominent areas of the town.

The street level of the Quadrant was used for shop units, one being that of B. W. Bentley, an artistic photographer, whose shop was reputed to be the first photographic studio in Derbyshire. It is not surprising that Buxton was used for his studio due to the popularity of Buxton with the fashionable and wealthy.

There are some existing original shopfronts. One noted shop in Buxton is that of Clowes Chemist. Both its original shopfront and wonderful original interior fittings are listed by English Heritage. This shop is remarkable to have survived not only redevelopment, but also the perils of road users. In both 1934 and 1961 the local newspaper reported that on each occasion a runaway lorry had crashed into the shops. Thankfully there were no injuries to either people or to the chemist's shop.

Above: Clowes Chemist on the south side of the Quadrant still retains original wooden fittings.

Left: Original art deco tiling in the Quadrant.

26. Christ Church, Burbage, 1860

By the middle of the nineteenth century Burbage was no longer a tiny hamlet but a suburb of Buxton, and its population, mainly employed in lime production or agriculture, was growing. The area did not have its own church and therefore no facilities for marriages or burials. E. W. Wilmot, the agent for the 7th Duke of Devonshire at that time and a philanthropic man, brought the situation to the duke's attention. The duke gave the ground for Christ Church and churchyard to Burbage.

Henry Currey was the architect responsible for the design and Christ Church was built in the Romanesque Revival style, with its uncomplicated arches, windows and decoration. It cost £2,600.

Burbage became a parish in its own right, with the building of the church and remained so until 1961 when it was incorporated to become part of Buxton.

Today Christ Church is notable for its 'clypping service'. Held on the last Sunday in July, the service is of Saxon origin and involves the congregation holding hands and facing outwards around the exterior of the church. It is said to represent an outward show of affection by the congregation for the church.

The church has stained-glass windows from the studio of William Morris & Co., designed by Edward Burne Jones.

In the churchyard is the grave of E. W. Wilmott. It is fitting that the man who was so important in the creation of this Grade II-listed Victorian church should be laid to rest there.

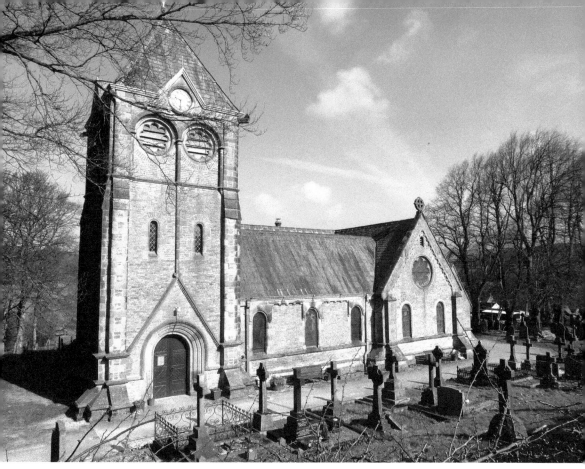

Above: Christ Church, Burbage.

Right: Interior of Burbage Church.

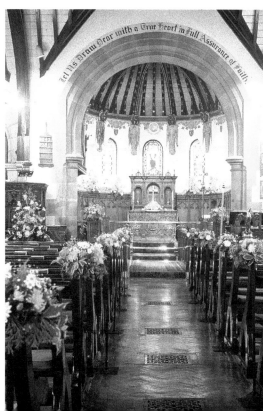

27. Railway Station, 1862

This station was built as one half of 'identical twin' stations, the other half being sadly demolished during the many railway closures in the 'Beeching' era of the 1960s.

The arrival of the railway to Buxton brought mixed feelings to the Victorian town developers. Although the trade through tourism that the railways would bring was invaluable, it was a matter of concern that, with two railway companies wanting to build lines and stations through Buxton, it would ruin the architectural character of the town. The answer lay with Joseph Paxton, architect and also a director for both of the rail companies concerned. These were the London & North Western Railway and the Midland Railway. Paxton used his position as director of the railway companies to ensure it was his design that was used for both of the stations.

They were almost identical and on adjacent sites. Each station had a great fan-shaped window gracing the end wall and adorning this window was the individual logo of the rail company it belonged to. Both stations opened on the same day: Saturday 30 May 1863.

The original stations shared a roof that covered the platforms but this was taken down in 1964. With the further decline of the railways, by 1967 the station for the Midland Railway line had been demolished. There was an attempt by the Buxton Steam Centre to reopen part of the Midland line towards Miller's Dale, but this idea was unsuccessful and now just one line remains.

The remaining station now serves the town. The great semicircular window was restored in 2009, the name London & North Western Railway still clearly marked out in the brickwork around it. Although it looks a little unfinished without its roof, the station, with its classical styling and brick façade, still has architectural features of merit and stands as testament to Buxton's railway past.

Railway station.

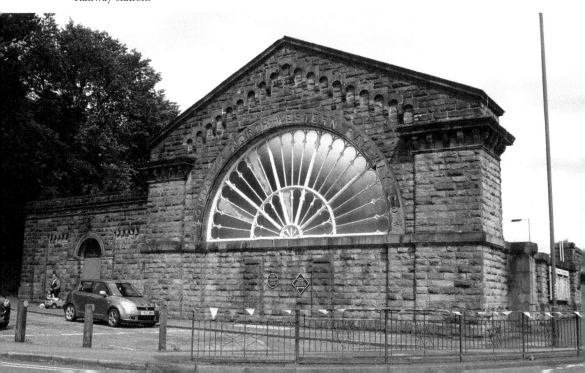

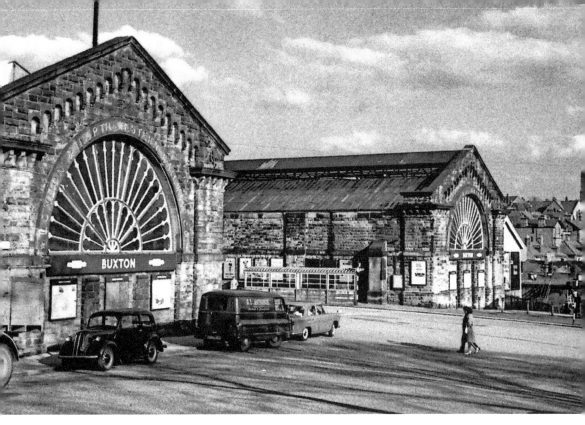

Postcard showing the two railway stations – the since demolished Midland Railway station is on the right.

28. The Palace Hotel, 1864

The Palace Hotel is a Buxton landmark situated on a hill above the railway station. Originally known as the Buxton Hotel, the Palace Hotel still displays the grandeur that it has always been renowned for. Built in the French chateau style by architect Henry Currey, its complex roof line, deeply pitched roof and turrets rest upon a design that is still in keeping with the Georgian buildings in the town.

The hotel has always been grand. When the opening celebrations were held, the local newspaper ran a story about it, something that was unheard of in the mid-Victorian years. The publicity heightened the popularity of the hotel and more tourists flocked to stay in one of its 122 rooms, set in 5 acres of landscaped gardens. The design included all rooms having the luxury of hot and cold running water and the hotel was later the first building in Buxton to have a telephone.

Although the hotel was a financial success, the company who had commissioned it ran into financial difficulties and the hotel was sold at auction. It was at this point in time that the building's name changed from the Buxton Hotel to the Palace Hotel.

In 1887 Robert Rippon Duke designed a large new dining room to the rear of the hotel. It had an iron roof and the interior was richly decorated with marble. The marble formed parts of the floor and walls and it had a majestic black and gold marble staircase. Fully approved of by the owners, Robert Rippon Duke then constructed a new wing to the west of the building also decorated throughout with marble.

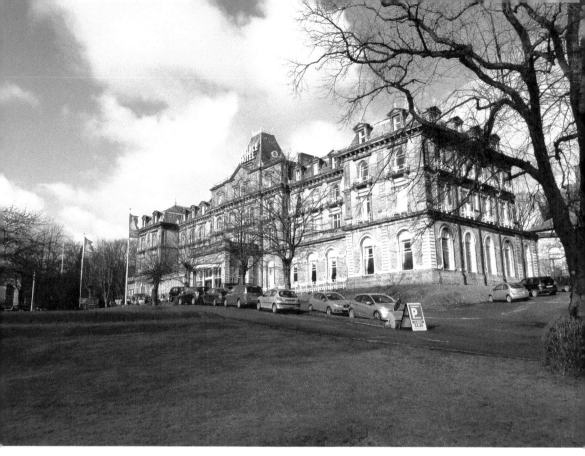

Above: Palace Hotel.

Below: Postcard of the Palace Hotel, 1929.

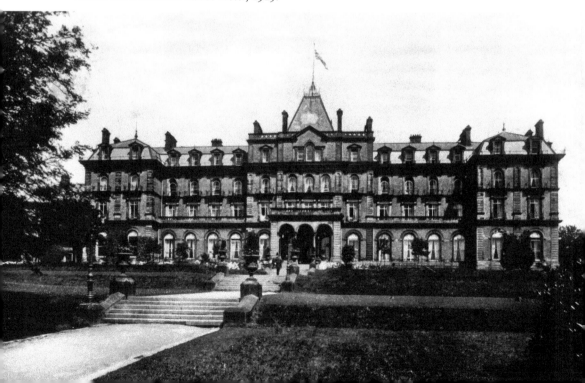

Although still much in demand as a hotel during the years of the First World War, the Palace Hotel chose to cease trading and allow the property to be used for the war effort. Canadian troops stationed in Britain made a base there and it was used both as a camp and a hospital by them.

By the 1920s the hotel was trading again and has been a host to many famous names. Today the Palace Hotel is the largest hotel in Buxton.

29. The Central Hall, the Pavilion Gardens, 1870

In the early nineteenth century, the 5th Duke of Devonshire decided to landscape ground behind the Crescent. He commissioned the extensive planting of trees and had a series of cascades created in the River Wye. The duke gave this area for use as parkland and recreational walks and so enhanced Buxton's popularity as a spa town. This park was the beginning of the Pavilion Gardens.

The Central Hall was the first of a series of buildings included in this parkland. The Buxton Improvements Company had recently been formed to fund town building projects and it was in the late 1860s that the 7th Duke of Devonshire proposed building, a 'Winter Gardens' that he would half-fund himself. He wanted a 'great conservatory' built to provide a sheltered environment for visitors to promenade in during cold and wet weather.

Central Hall, the Pavilion Gardens.

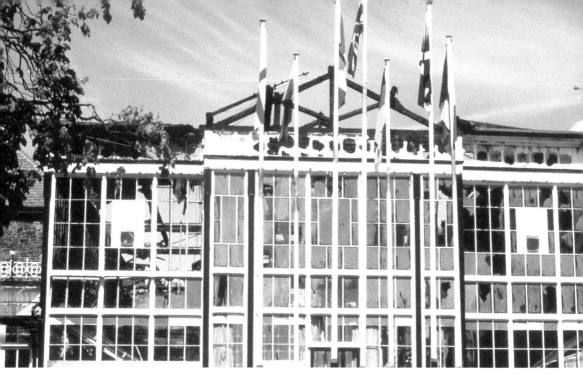

Above: The Central Hall following the fire in 1982.

Below: The footbridge designed by Edward Milner.

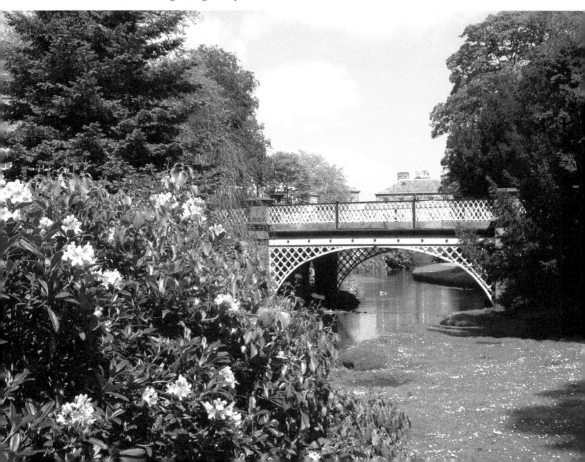

The Grade II-listed Central Hall was the realisation of the duke's idea and was designed by Edward Milner in 1870. Milner had trained under Joseph Paxton, the architect of London's Crystal Palace. The cast-iron and glass building is unusual. It is one of the oldest winter gardens still surviving in the country and its inland setting is unique. Similar buildings are usually in a coastal setting.

There is a long promenade in front of the hall and its adjoining buildings, and from it is a lovely view of the river and gardens. A Grade II-listed footbridge, also by Milner, spans the river and there used to be a bandstand designed by him. The bandstand was burnt down and now a twentieth-century replacement is on the site.

The Central Hall caught fire in 1982. Fortunately, its structure survived mostly intact and it was rebuilt in 1984 as a restaurant, shop and café. The main loss architecturally was the original large arched windows, which were replaced with smaller rectangular ones.

Although the original concept of a 'winter gardens' as an area to promenade in has become outdated, the Central Hall and its café environment still provides the shelter and entertainment that the 7th Duke created.

3c. Broad Walk, 1861–76

Although the Broad Walk is the name of a street, it is a street that is defined by the distinguished Victorian and Edwardian villas that line it.

The construction of Broad Walk began in 1861 when local wine and spirit merchant G. F. Barnard erected the first three houses there. These are known as Cavendish Villas. Further development occurred soon after and the houses on the wide gravelled walk

Grosvenor House, Nos 1–4 Broad Walk, built in 1864 for local hotelier Brian Bates.

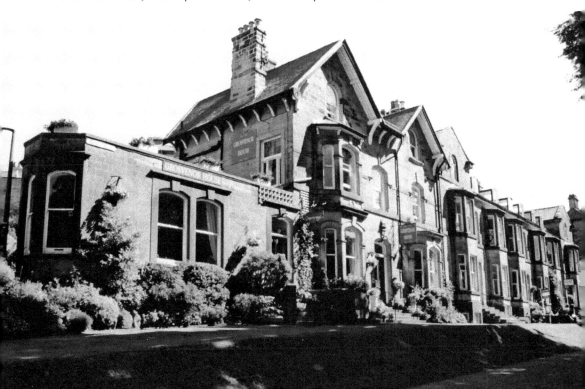

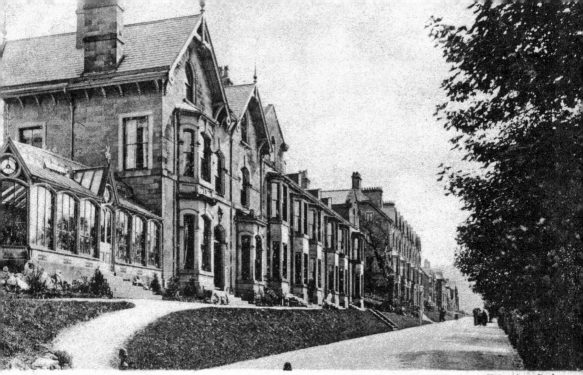

The Broad Walk, Buxton

F. Wright, Stationer, Buxton. Valentines Series

Above: Postcard showing Grosvenor House with the original conservatory.

Below: Lamps on Broad Walk, part of Henry Currey's original layout.

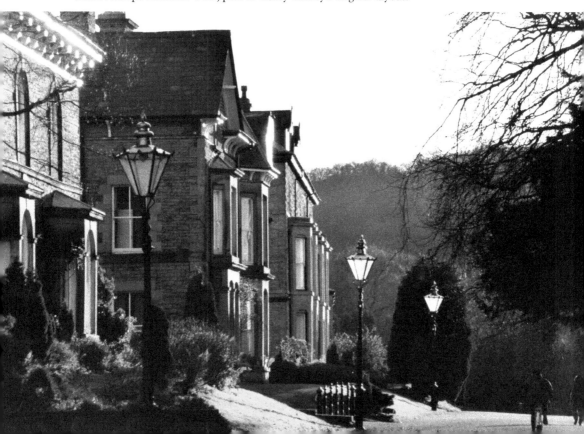

leading from the Old Hall Hotel to the Tonic Bath soon became one of the most fashionable Victorian terraces in the town.

By 1864 there were ten dwellings, all private lodging houses. Some were designed by Robert Rippon Duke or Henry Currey. The Devonshire estate controlled the style of the buildings to ensure they were in keeping with the surrounding Georgian architecture. The skill of the architects produced classic Victorian buildings with bay fronts and complex rooflines.

The Broad Walk, with its ornate lamp posts, is still a peaceful leafy street. It is in a conservation area and many of the properties still retain their original features – inside as well as out. Many also retain their original purpose and plenty of guesthouses still occupy the terrace. As a nod to the nineteenth-century heritage of the street, one simply is called 'The Victorian Guest House'.

31. The Savoy, 1874

Originally known as the Burlington Hotel, this property is on the site of one of the houses that stood at the bottom end of Hall Bank.

Designed by Robert Rippon Duke and built by James Turner, the Savoy is Grade II listed and features include a different design of stonework on each of the four floors. It is a little different to the majority of Victorian architecture in central Buxton as the protruding oval wing displays characteristics of the Arts and Crafts movement in the shaping of its roof.

The Savoy Hotel.

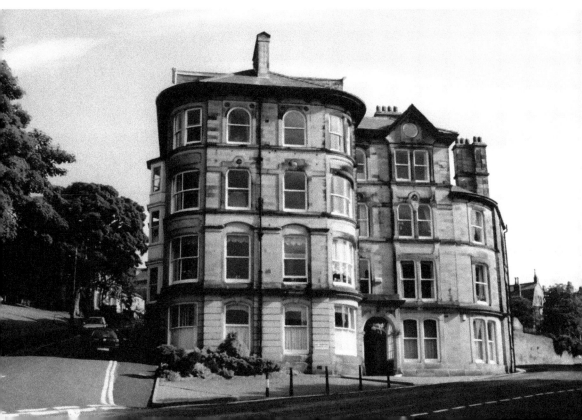

One of the Savoy's bars used to have a Spanish theme and was a popular venue in the 1940s and 1950s. The nearby Pavilion Gardens held regular Saturday night dances but were unlicensed at that time. As the Savoy Hotel was in close proximity, it was a convenient place to go to buy a drink when taking a break from the dancing.

The hotel closed and was converted to apartments in the 1960s; however, many of the Victorian interior features have remained.

32. The Octagonal Hall, Pavilion Gardens, 1875

The completion of the central hall in Pavilion Gardens created a venue for the Buxton Town Band to perform in. Prior to its construction, the band had always played outdoors and in inclement weather the audience suffered or stayed away.

The concerts in the Central Hall proved so popular that the spectator space was no longer sufficient. It was a regular sight to see parts of the audience sitting on the stone sills outside the hall and standing crowds straining for a glimpse of the players.

To create more space, the planning proposal was forwarded for the Octagon Hall. It was designed to hold 2,000 people. The foundation stone was laid on 30 December 1875 and the building began to a design by Robert Rippon Duke. He managed to produce a seamless join between his new work and Milner's Central Hall.

The Octagonal Hall, Pavilion Gardens.

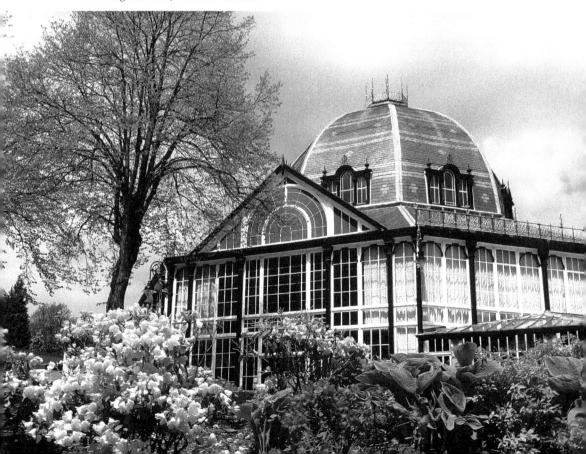

Morris dancers performing in front of the Octagonal Hall during the annual Buxton Festival.

What Duke created was this Grade II-listed building. Stone foundations support an octagonal hall comprising of cast iron, timber and glass. The slate roof is topped with an impressive eight-sided dome that is iconic in itself, but also, perhaps, a reflection of the great Devonshire dome nearby.

In 1968 the council proposed to demolish the building. It went to vote and fortunately the Octagon Hall was saved by a margin of just one vote. The hall has continually been in use as a venue, but in 2015 it was discovered that the roof was unsafe. The building was forced to close pending repairs. A £3 million restoration project has been undertaken and the Octagon Hall is due to reopen imminently.

33. Devonshire Hospital Drinking Well and Pump Room, Water Street, 1882

In 1876, a charity-funded hot baths was built on a large new site in Buxton. Used by the Devonshire Hospital for the treatment of those who could not afford hydropathy themselves, it attracted many more people into the town. The bathhouse catered for those patients who had immersion therapies, but those who wished to drink the mineral water went to St Anne's Well, along with any other visitors to Buxton who wished to 'take the waters'. In 1881 a trustee of the Devonshire Hospital brought it to the attention of the town

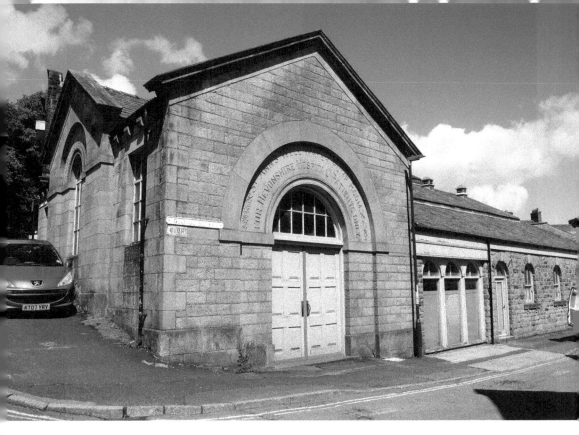

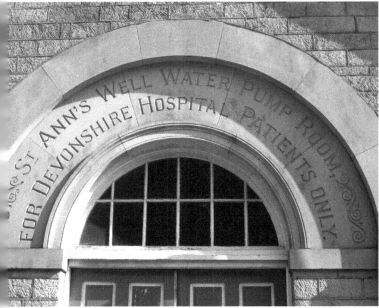

Above: Devonshire Hospital pump room and drinking well.

Left: Detail of the Devonshire Hospital well.

planners that the amount of hospital patients queuing in the Colonnade near St Anne's Well, waiting to take the waters, was causing annoyance to the more well-to-do visitors.

A suggested solution was a structure to house a separate well where the charity patients could take the waters. Robert Rippon Duke designed a building that was erected in the yard adjacent to the engine house of the Charity Hot Baths. The water was pumped up

from the Natural Baths into the new building and a pump room created exclusively for the hospital patients to drink Buxton water.

Although built a century after the architectural masterpiece of the Crescent, the hospital drinking well and pump room has a design that is totally in keeping with the Georgian architecture that is prolific in Buxton. It also has similarities with the nearby railway station as it too has a large inscribed arch on its gable end.

Now no longer used for any hydropathic purpose, the building still contains a large Victorian gravity pump that was used to pump water from the natural spring directly to the Devonshire Hospital as it stands on a site elevated from the water source.

34. Old Court House (the Promenade Room), Water Street, 1886

From the moment it was built, the Old Court House has been used as a place for the townsfolk of Buxton to congregate and converse.

The property has been constructed in a simple and classic style with little ornamentation. The only distinguishing element being that its façade is, curiously, studded with gargoyles from an unknown source.

Originally known as the Promenade Room, the Duke of Devonshire allowed the building to be used for concerts until he gave 12 acres of land to the newly formed Buxton Improvements Company for them to provide permanent indoor amenities for the town. The land he gave became the present Pavilion Gardens.

The Promenade Room was now redundant and given another use. It became referred to as the Court House and was a place for public meetings and occasionally an inquest, as was the case of Edwin Worrell, who was fatally injured when building houses designed

Old Court House.

One of the gargoyles on the front of the Old Court House.

by Robert Rippon Duke. A verdict of accidental death was recorded after he was hit by a falling chimney stack.

The property has been a Masonic lodge and also served as estate offices for the dukes of Devonshire. In the 1950s the lower floor of the building was converted to become a car showroom. Later conversions have followed and it is now occupied by boutique shops, bars and eating places. In the heart of Buxton's café quarter, the Old Court house is still a popular place for meetings.

35. Wye House, Corbar Road, 1862

This property, built high above Buxton, was designed in the French chateau style and on completion was known as Corbar Hill House. Said to have been built for a lady in the Ryder family, who was close to the duke, it was surrounded until recently by formal gardens.

The building has perfect symmetry. The elegant frontage is studded with oval, highly decorative windows and its Westmoreland slate roof is crowned with pinnacled turrets. It is set on a slight bank with steps leading up to the front door from the drive below. Built at a time when it was said that the higher your social standing, the higher also was your dwelling place, Wye House certainly has the loftiest views of the town.

The name of the property changed to Wye House in 1901 and was used for some time after the Ryder family left as the John Duncan School for children with special needs. It lay derelict for several years before being refurbished in 2008.

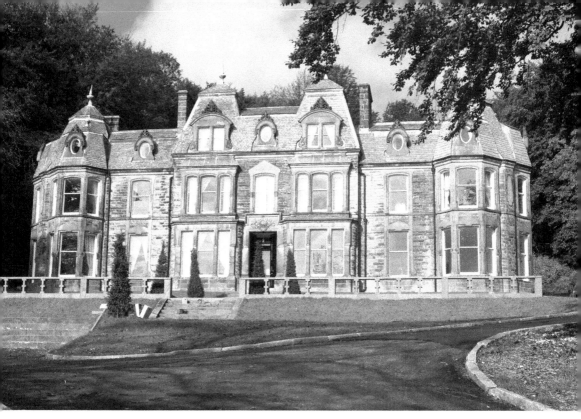

Wye House, Corbar Road.

Renamed The Chateau, it became an upmarket hotel and spa, but the business was not a success and closed. Wye House was later converted to apartments. The formal gardens were lost when the land was used to create a separate apartment block. Also lost was a Victorian pool used by the household and guests for the sport of curling. In winter this square 'curling pond' would freeze to allow this fashionable winter activity to take place.

There used to be another Wye House, confusingly also on Corbar Road. This was an institution named 'The Buxton Establishment for The Care and Treatment of the Insane Of The Higher and Middle Classes'. It no longer exists, having been demolished to create a housing estate.

36. The Peak Hydro, Terrace Road, 1881

The Buxton Hydropathic Company was created in 1880 with Dr Hyde of Buxton House at the head of the board of directors. The company hoped to raise enough money to purchase seven lodging houses adjacent to Buxton House. The plan was to rebuild these to become one wing of a new and bigger hydropathic establishment, with a further wing to match on the other side of a central building. The funds could not be found and the company went into liquidation. The building was sold on and the construction continued but was fraught with other problems. This included getting approval for the architectural design. After much negotiation with town planners the design was finally passed and the Peak Hydro was completed. Dr Hyde expanded his own business into the much larger building and continued to be proprietor.

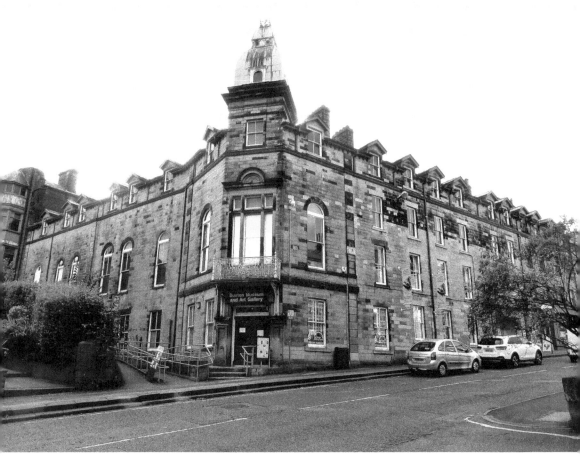

Above: The Peak Hydro.

Left: Stained glass, Peak Hydro.

When the hydropathic 'bubble' burst at the turn of the 20 twentieth century, many businesses closed. Dr Hyde went bankrupt and the building was repossessed, although it continued to trade for a while.

By the First World War, the Peak Hydro had been put to other uses. The building was utilised to support the war effort and became part of the Granville Hospital, run by the Red Cross. It was used to treat Canadian troops and was later a hostel for them while they awaited demob.

The property was sold to the borough council in 1926 and used as the Buxton town library and museum. The library was relocated in 1974 and that meant the museum was able to expand. It was now known as the Buxton Museum and Art Gallery. The building underwent another major £1.5 million revamp in 2017.

Following the careful renovation of the Peak Hydro, the building still displays its Victorian features. Wrought-iron railings adorn the top of the entrance door, which is, in turn, glazed with stained glass.

The turret that crowns the central link between the two large wings of the building is now given over to Verdigris, but inside many original fittings have been restored to their former glory. Looking around Buxton Museum, with its many interesting artefacts including Ashford black marble and the Buxton Bear, it is also worth looking at the museum's interior, with the fine Victorian plasterwork that still remains unchanged from its days as a fashionable Hydro.

37. The Clubhouse, 1886

The Old Clubhouse is now a popular sports bar on Water Street in Buxton. The interior is rich with polished wood and it has original Victorian bar fittings. There are large fireplaces

The Old Clubhouse.

Sign on the Old Clubhouse.

with mirrored overmantels and stained-glass decorates throughout. This sophisticated interior does much to reveal the origin of the building. It was originally built to be a gentlemen's club.

The property was designed and built in 1886 by local architect William Bryden. Bryden had taken over Robert Rippon Duke's business in 1883 when Duke had a spell of retirement due to ill health.

The Grade II-listed building is now clad in ivy and this, combined with its Tudor-style gabled doorway and front wing topped with battlements, implies great age. However, the simple sash windows of the upper storey, Lakeland slate roof and ornate terracotta ridge tiles all show it to be a result of Victorian design.

When originally built, the building was known as the Union Club. Purposely built, it provided a venue for members of any of the well-known London clubs to use when they were in Buxton holidaying and receiving spa treatment. If a man was the member of a gentlemen's club he had automatic membership of the Union Club. When the Union Club closed in 1969 the building was converted to become a public bar.

38. The Town Hall, Market Place, 1887

Prior to the present structure being built, the Town Hall in Buxton had been on Eagle Parade. It was used solely as a meeting place for townspeople as the concept of a town hall as an administrative centre had yet to develop. The local board met in the Court House to

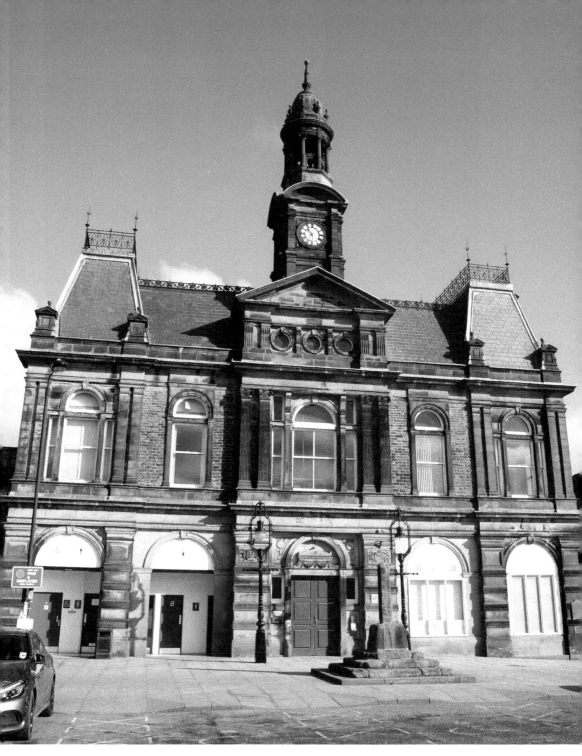

The Town Hall.

Bust of Lord Frederick Cavendish, Town Hall.

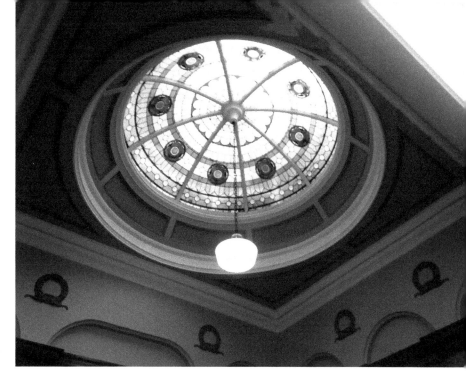

Roof light
in the Town
Hall.

deal with local affairs but as Buxton grew this became unsuitable and a designated place to deal with town business was suggested by Robert Rippon Duke.

It was a while before a suitable site could be found, but after a disastrous fire burnt down the Market Hall in September 1885 it was decided that the plot was ideal to use to build a new Town Hall. The fire was started when an unattended paraffin lamp in one of the shop units in the market hall caught light. Although Buxton's brand new fire engine was called, the building was raised to the ground. The market hall was a utilitarian structure designed by Henry Currey and not popular. It was described at the time in the Buxton Advertiser as 'of no architectural value and objectionable in every way'. Rather than rebuild the market hall, the site was cleared and used for the new town hall instead. The building was designed by W. Pollard of Manchester and the foundation stone laid in 1887.

Built from stone quarried at nearby Nithen Quarry in Corbar, it is built in the French Renaissance Revival style. Typically, it has a mansard roof with iron cresting and an eye-catching clock tower with cupola. The frontage boasts Victorian-style lampposts.

The clock was donated by the Duke of Devonshire's tenants in memory of Lord Frederick Cavendish, who was assassinated in Dublin in May 1882. Frederick was the duke's son and went to Ireland as chief secretary to the viceroy. Only three days later, at the age of forty-five, he was stabbed to death with a surgical knife in Phoenix Park. There is also a bust of Lord Cavendish on display within the Town Hall. The interior has some fine original plasterwork and stained-glass roof lights.

As Buxton grew it became harder to make one building stand out above the rest in style or size. Architects of new properties had to think of innovative ways to make their building a landmark. The French chateau-style roof of the Town Hall, with its dominating clock tower and cupola, was the means Pollard used to ensure his design had features that stood out. It can be viewed from many places in the town. It rises above surrounding buildings and also above the heightening tree line, still enlivening the Buxton skyline today.

39. The Paxton Suite, St John's Road, 1889

In 1889 W. R. Bryden designed a new theatre for Buxton. Built on a site behind the Central Hall of the Pavilion Gardens, when it opened it was called the Entertainment Stage. The theatre opened to a performance by Victorian comic actor John Toole. Often renamed, the building soon became known as the New Theatre.

In 1903, there was intensive remodelling done to the buildings of the Pavilion Gardens. The Opera House was constructed and after the opening of this new venue, the Paxton Suite was no longer used as a theatre. It was fitted out with equipment to show silent films and became a cinema. Called the Hippodrome, this cinema was open until 1932. When the Opera House was refitted in 1932, it yet again took over the job previously held by the Paxton Suite and became Buxton's cinema. The Paxton Suite reverted to a theatre, with the new name of the Playhouse. During the 1950s it was host to a repertory company's annual performances; A small forerunner to the famous Buxton International Festival.

The Paxton Suite today is a modern flexible performance space. Redesigned in 2010 to be either a ninety-seat studio theatre or 360-seat auditorium, the contemporary design seamlessly blends the original late Victorian features with state of the art facilities and

Detail of carving on the Paxton Suite.

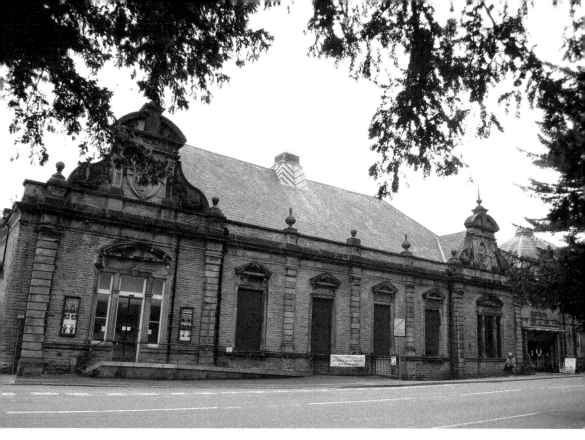

The Paxton Suite.

technology. The interior is, perhaps, more impressive than the exterior, which has sadly lost its enclosed portico. However, with decorative finials on a stone balustrade and a simple classic-style frontage, the Paxton Suite (or the Pavilion Arts Centre, which is its current title) is still an inviting venue for theatre-goers.

4c. The Pump Room, 1894

The Pump Room was built 1894 and given to the town of Buxton by the 7th Duke of Devonshire. It was designed by Henry Currey and opened to the general public in 1889. The idea of the Pump Room was for it to be a place where, for a penny a glass, people could partake of the waters in dignified surroundings. The alternative was to queue at St Anne's Well, where the water was free to all, but it was outside. The premises were opulent and fashionable and its popularity was heightened when Edward VII took the waters there in 1905.

Both the mineral water and iron-bearing chalybeate were seen to flow through five massive silvered fountains. There were intricate plasterwork decorations and marble floors of green and white. A balustrade – also marble – protected the water source. As it was heated throughout with radiators and had electric light fittings, the Pump Room was very luxurious.

The flat roof of the building was used as both a container garden, as it could be seen from the Slopes, and in the event of town celebrations the roof played host to hundreds of

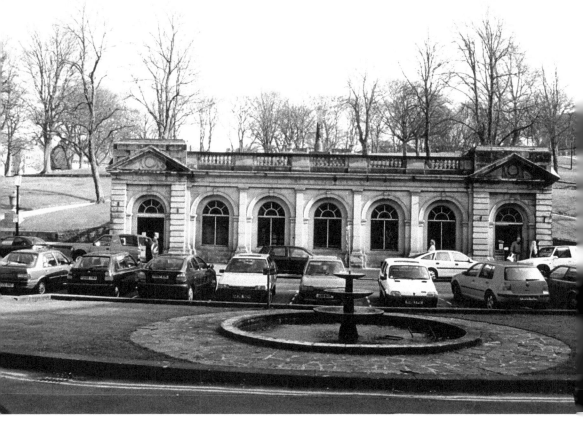

Above: The Pump Room.

Below: Postcard of the Pump Room before the domes were removed and the open arcading filled in.

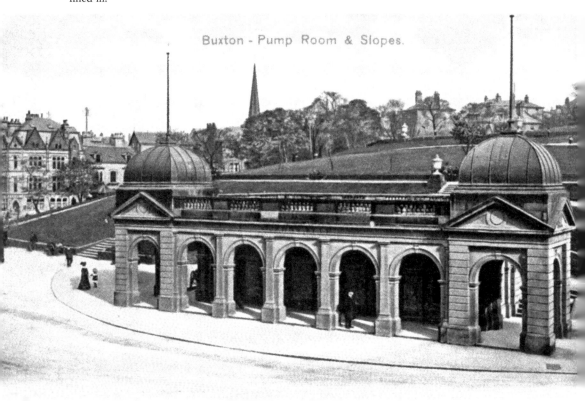

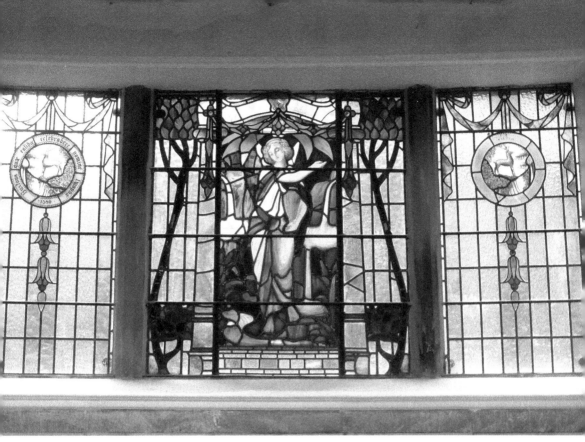

Above: Window in the Pump Room.

Right: Interior of the Pump Room.

spectators trying to get a view of civic proceedings. The roof originally had twin cupolas with flagpoles, but these were taken down in the 1950s when it was considered too expensive to restore them. Built with an open façade, this colonnade was closed in 1912.

The Pump Room was eventually abandoned, but in 1981 Britain's first 'micrarium' opened. Featuring a series of nearly fifty microscopes connected to projecting screens, the public could study the microscopic wonders of nature. This ranged from crystals melting and reforming to ants tirelessly toiling away. The attraction was developed by Stephen and Janet Carter and attracted over 40,000 visitors a year. It was voted museum of the year in 1985, but closed in 1995 following the death of Stephen.

With the forthcoming reopening of the Crescent, the Pump Room is being restored to its former glory. Visitors will once again be able to see the magnificent Grade II-listed interior, with its plasterwork and marble and stained glass, featuring the crests of Buxton, Cavendish and Devonshire. The Pump Room will return to being a place to take the waters as it becomes part of the Crescent Heritage Experience.

41. Sevenways and Somersby, College Road, 1896

The pair of Arts and Crafts semi-detached properties, Nos 1 and 3 College Road Buxton, were originally known as Farringford and Somersby. When No. 1 later changed its name to Sevenways, the subtle nod to a literary hero of the Arts and Crafts movement – Alfred, Lord Tennyson – was lost. The names of the houses came from Tennyson's birthplace in Somersby rectory in Lincolnshire, and the house he later lived in at Farringford, Isle of Wight.

Sevenways and Somersby, College Road.

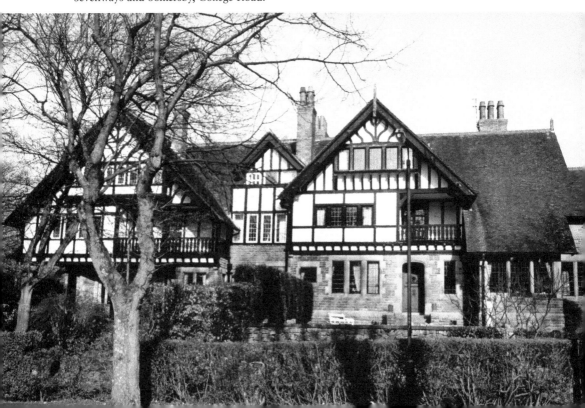

The buildings are Grade II listed and were designed and built in 1896 by Barry Parker and Raymond Unwin. Parker's father was a bank manager in Buxton and, after studying under Faulkner Armitage, a major designer within the Arts and Crafts movement. Parker came to Buxton to complete three building projects for his father.

The first two projects were Sevenways and Somersby. They are built using the Cheshire Domestic Revival style with their extensive exposed timber and studwork. The two houses also feature Tudor-style doors and a mullion window, with large oriel windows above. Both feature balconies and deep-pitched cross-gabled roofs.

The interior of Sevenways is largely intact and features include a corner fireplace, with its original copper canopy and an inglenook fireplace in a painted brick arch. Most of the internal doors in No. 1 are original. The interior of Somersby has been modernised to a degree, but it still has some of its original fireplaces and has retained its lovely stone staircase.

Although the semi-detached properties are private houses, they are set just off the roadside in plain view. Any passer-by can easily see why these are such excellent examples of their genre.

42. Green Moor, Carlisle Road, 1898

Green Moor on Carlisle Road was the final commission for the partnership of Raymond Unwin and Barry Parker in Buxton. Working together was a natural step for them as, apart from both being a part of the Arts and Crafts movement, they were also brothers-in-law. Parker and

Green Moor, Carlisle Road.

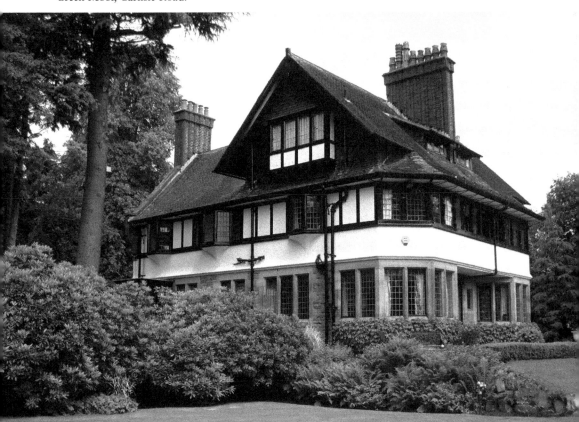

Unwin would later be important figures in both town planning and improving social housing, but their early work at Buxton was definitely not designed with the working classes in mind.

Green Moor was built in 1898 in an Arts and Craft style that is often described as 'eclectic'. The true term is Vernacular Revival and refers to the individual style given to this and other similarly exclusive designs in Arts and Crafts properties. It is said that the trend for Domestic Revival styles developed when the young designers and architects went on daytrips to the countryside. Using either the railway or bicycles, which, by the turn of the twentieth century, people had easy access to, a trip to the rural villages and the sight of some of the remaining Tudor dwellings was a romantic notion of domesticity for the followers of the Arts and Crafts movement. The designers captured this vision and applied it to their work.

This Grade II-listed building is Parker and Unwin's finest house in Buxton. It features a continuous oak-framed window curving around the corners of the first floor. Other windows are mullioned, casements or oriel and all feature leaded lights. The subtle use of black-painted timber framing and white plasterwork is enhanced by the plain slate roof. The roof is set with dominant brick chimneystacks.

Situated within landscaped gardens, this house is both a desirable dwelling and an architecturally valuable piece of property.

43. The Opera House, 1903

Over the last 200 years Buxton has had four theatres. Two of them – one in Spring Gardens and one at the end of Broad Walk – were demolished in the eighteenth century. The third –

The Opera House at night.

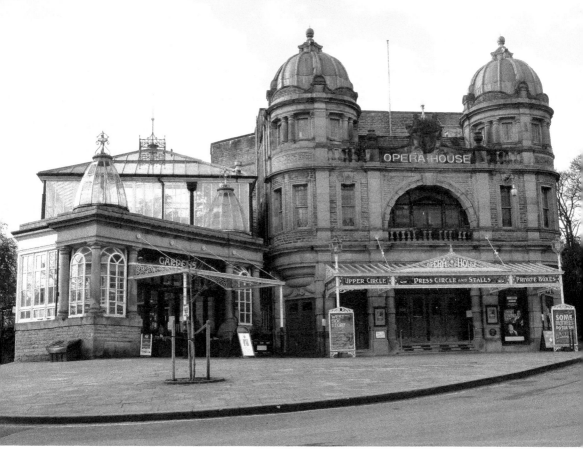

The Opera House.

the Entertainment Stage – still exists as part of the Pavilion Gardens complex. The fourth to be built, and by far the most iconic, is the Buxton Opera House.

In 1901 John Willoughby, who was secretary of the Buxton Gardens Company and general manager of the Pavilion Gardens, decided the time was right for a new theatre in Buxton. He engaged Frank Matcham to draw up plans for it on a site by the Pavilion Gardens. Matcham was the most prolific theatre architect of his time, among his ninety designs are the London Palladium, the Hippodrome and the Hackney Empire. The Buxton Opera House opened on 1 June 1903 with a play, 'The Prologue', written specifically for the occasion. The theatre has since been described in FT Magazine as 'a near ideal marriage of size, acoustics and beauty'.

Matcham's Edwardian masterpiece, designed in the Italian Renaissance style, was the last of the large public buildings to be constructed in Buxton. This Grade II*-listed building is a landmark. The twin ribbed domes are lead-clad and sit above the entrance doors and large, central arched window. The intricate iron and glass canopy is set with wonderful art nouveau glasswork and octagon glass lanterns hang above. The Welsh slate roof is finished with a stone parapet incorporating a crest and is inscribed with the words 'Opera House'.

The interior is as iconic as the exterior. Designed in baroque revival style, the auditorium boasts cherubim, ceiling paintings and gold leaf decoration throughout. The foyer and

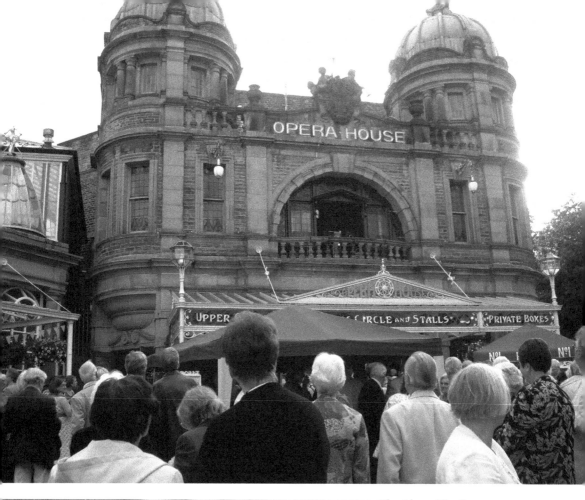

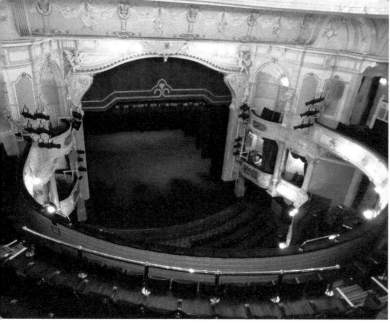

Above: The Opera House during the annual summer festival.

Left: The Opera House interior.

stairs are enhanced with art nouveau glasswork. The interior is largely untouched and the original gas fittings, used for heat and light at the time the theatre opened, can still be seen.

The theatre went into decline at the start of the Second World War and from 1942 was used as a cinema with occasional performances from local amateur societies. The Opera House finally closed in 1976 and it was feared that it would remain closed due to lack of interest in stage productions. However, the borough council decided to restore and relaunch the building with much promotion and it reopened in 1979. The Opera House had a complete restoration and an orchestra pit was added, which meant the auditorium could finally be used as a music venue. Since then it has been the host of Britain's largest opera-based event, the Buxton International Festival, when for two weeks in July Buxton becomes a leading arts destination. For the other fifty weeks of the year, the Opera House is still a prestigious theatrical venue and holds over 400 different performances every year.

44. Milnthorp Homes, Macclesfield Road, 1904

Joseph Milnthorp was a well-known philanthropist and had been a regular visitor to Buxton for over thirty years before finally retiring to the town. In 1904 he donated £10,000 in cash for a series of twelve almshouses to be built at Wye Head on Macclesfield Road. The land had been donated by the Duke of Devonshire. Together with his friend Thomas Hampson, the pair instructed architect W. H. Bryden to design the properties. The plans were drawn up and the building work was carried out by G. H. Bagshawe & Sons.

The concept for Milnthorp House was for it to be 'a dwelling for four old men, four old women and four old married couples'. The properties for couples each had a bedroom, kitchen with coal burner and pantry, sitting room with coal fire and outside toilet. The eight single-occupancy houses had a bedsitting room with coal fire, kitchen with coal burner and pantry and outside toilet. A trust fund provided furnishings for all the houses and the occupants also benefited from an allowance of 4s a week for single people and 7s a week for a couple. A ton of coal per year and a Christmas gift of a joint of meat were other perks for residents.

The Milnthorp Homes are still run by a non-profit-making organisation. Later improvements to the houses have been the addition of bathrooms, indoor toilets and the replacement of the original coke burning, cast-iron stoves with modern oil-fired boilers. These improvements were overseen by Peter Hampson, grandson of the cofounder, Thomas. Peter was involved with the properties for seventy years as trustee and consultant before he retired in 2008.

The Milnthorp homes are Grade II listed. Stone-built with mullioned windows and a red tile roof, the roof is further enhanced with terracotta ridge tiles and chimneypots. The property has large stone gables above the windows, which dominate the front and are very ornate. The central gable has a plaque inscribed 'Milnthorp Homes' and the date of construction.

This gently curved single-storey terrace is set in its own neat garden and is as pleasant a place to live now as when it was originally conceived and built by the humanitarian Mr Milnthorp.

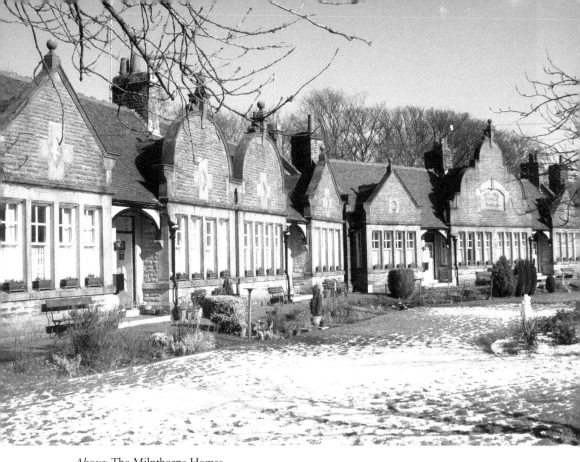

Above: The Milnthorpe Homes.

Below: Postcard showing the Milnthorpe Homes in 1906.

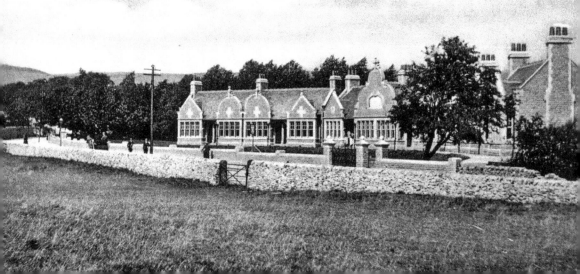

MILNTHORP HOMES, BUXTON.

45. Boots Store, No. 62 Spring Gardens, 1905

It is said that Jesse Boot came to Buxton for spa treatment for his rheumatism, and while here decided that this was an excellent place to open one of his stores. A store was opened at No. 42 Spring Gardens in 1900 but proved so popular that a purpose-built building was erected next door and finished in 1905. The site was at Nos 46–48 Spring Gardens and, due to high demand, it was seamlessly extended a year later into the unit next door. The extension fits perfectly with the original. Spring Gardens has since been renumbered and the shop now has 'No. 62' as its address.

Albert Nelson Bromley was the Nottingham architect who designed the Boots shops. Many were faced in camel-coloured glazed terracotta, as is the case with the Buxton store. Featuring a shaped gable, some of the stores held a corner position, but the basic design was altered by Bromley for smaller sites to good effect.

Although a simpler version of some other Boots stores, the first of which was the Central Depot in Nottingham, Buxton's shop still featured the striking art nouveau design of the others. Prior to alterations in the 1950s, the shop had an iron canopy to the front for those who wished to browse in the elegant curved display windows out of inclement weather. These windows were topped with classic art nouveau designs. The store had an oak staircase leading to an upper floor. The first floor contained a popular café known as

Boots store, Spring Gardens.

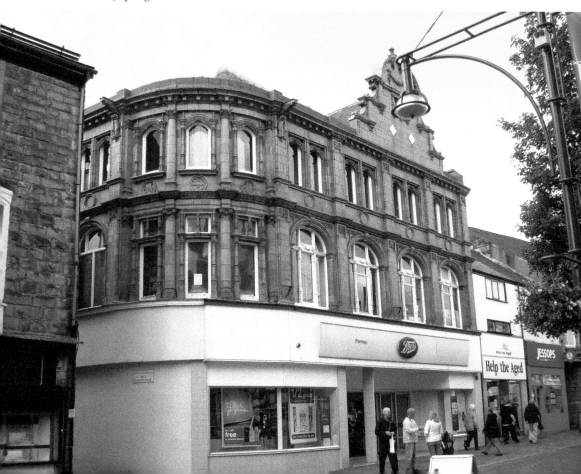

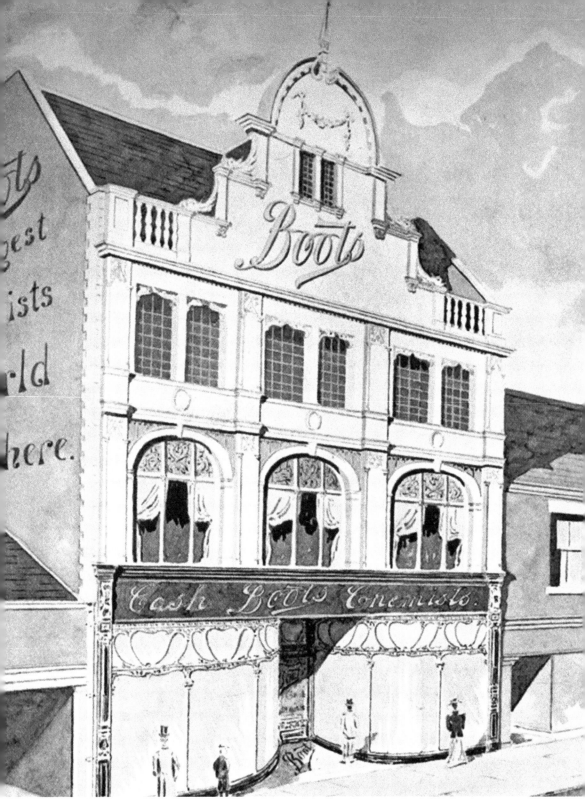

Boots store prior to being extended.

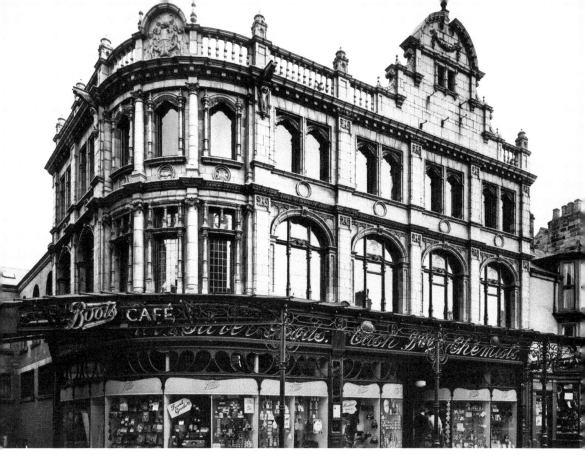

Above: Boots store showing the art deco windows prior to modernisation.

Right: Menu from the café at Boots.

Boots
CAFÉ RESTAURANTS

BIRMINGHAM	- Colmore Row and Bull St.
BRIGHTON	157-162 Western Road
BRISTOL	- 9-10 Wine Street
*BURTON-ON-TRENT	- 161 High Street
BUXTON	- 46-50 Spring Gardens
CHELTENHAM	- 129-131 High Street
DERBY	45-51 St. Peter's Street
*EASTBOURNE	99-103 Terminus Road
GLOUCESTER	- 31 Northgate Street
LEICESTER	34-36 Gallowtree Gate
LINCOLN	- 280-281 High Street
*LIVERPOOL	Boots Corner, Church Street
LONDON	- 182 Regent Street, W.1
NOTTINGHAM	High St. and Pelham St.
PLYMOUTH	- 18 George Street
*ST. ANNES-ON-THE-SEA	
(Season only)	St. Annes Road West
SHREWSBURY	- 7-8 Pride Hill
SOUTHEND-ON-SEA	- 130 High Street
SOUTHPORT	- 387-391 Lord Street
TORQUAY	- 46-54 Fleet Street

*Cafes are available for Dancing, Private Parties,
Whist Drives, &c.*

Terms on application to the Management.

**Denotes cafes not suitable for Dancing.*

TEA MENU

Boots
CAFÉ RESTAURANT

the Oak Room and a lending library. The café featured oak panelling with an open fire and the customers could enjoy the sound of a trio playing music. The waitresses wore lace caps and pinafores.

When the store was modernised in 1959, the upper floors were closed off and the staircase removed. The shopfront was also completely altered. The curved glass windows and canopy were removed and nothing at street level now remains of the beautiful art nouveau design. To look up to the higher floors, however, is to still witness the original terracotta tiling, original windows and nestling just below the eaves on the corner section, two lovely art nouveau figures still display Albert Bromley's design.

46. St Mary's Church, Dale Road, 1917

The foundation stone for this wonderful example of an Arts and Crafts church was laid by the Duchess of Devonshire in 1915, and the church was completed and consecrated two years later.

The church of St Mary the Virgin was built to replace the 'tin church', a temporary building constructed of timber and galvanised iron that had been put up rather cheaply in 1897. Miss E. Mirrles, a wealthy woman whose family owned an engineering business in Stockport, wanted the area of Higher Buxton to have a mission church. She donated £500 for the erection of a temporary building and payment for a priest for four years. The resulting building was the tin church.

St Mary's Church, Dale Road.

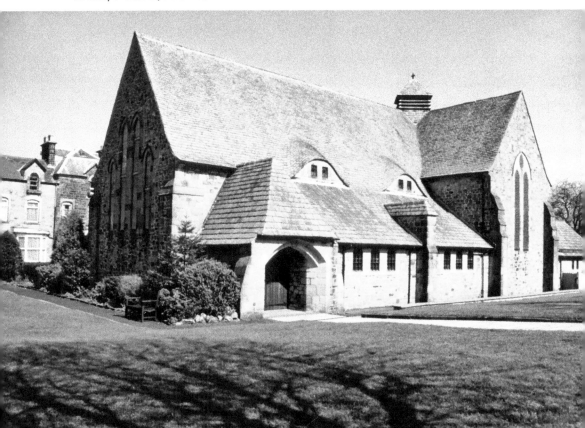

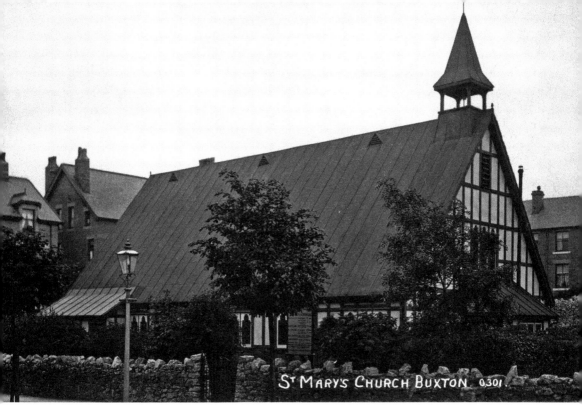

St Mary's Church Buxton. 0301.

Old tin church of St Mary.

When the Duke of Devonshire donated land to the parish in 1914, the vicar at the time arranged for his architect brother to design a stone church to replace the temporary one. Paul Currey was appointed in 1914 to design the new church and his legacy is this rare example of the Arts and Crafts tradition in church architecture. The church is also unique as it is one of very few built during the First World War.

The windows of this Grade II-listed building are known as eyebrow dormers and are one of the key external features of the church, sitting as they do in the steep nave roof. The long low roof curves out slightly at the base. The windows are small and unadorned, yet still allow light to enter the interior. The simple style of the interior is in keeping with the domestic style used by the Arts and Crafts movement. Much of it is whitewashed, set off with wooden beams and carvings. There is no graveyard in St Mary's, but the peaceful grounds offer a place for reflection and contain a war memorial to those who fell in both world wars.

The old tin church was sold to the army and continued to be used as a barracks chapel for some years.

47. The Swimming Pool, Pavilion Gardens, 1972

Before 1972 the only swimming facilities in the town were the small shallow pool within the Natural Baths and this was used mainly for therapeutic purposes. A private pool existed at the Palace Hotel, but this was only occasionally made available to the general public. The Lido, an open-air pool, was opened on Lightwood Road in 1936 during the height

Above: The Swimming Pool, Pavilion Gardens.

Below: Interior of the swimming pool.

of the popularity for outdoor swimming. It operated for a few years but due to Buxton's bracing climate it was little used and fell out of use after the war.

The present swimming pool was designed by John Poulson. Poulson was well known for his brutalist architecture. The term 'brutalist' comes from the French phrase 'breton brut', which translates to 'raw concrete'. The Brutalist movement were working from the 1950s to the 1970s. A lot of the public buildings built in this style have been described as 'ugly and harsh', but beyond the utilitarian concrete cladding, interesting comparisons can be made. The pool has a simple façade with elongated windows, and it has a columned palisade and a slate mansard roof. These same features are evident in many of the listed Georgian and Victorian buildings in Buxton. The pool, though modern, complements the town's architectural style.

John Poulson was also known for less artistic reasons. In 1972 he was charged with corruption. He was accused of winning contracts for municipal buildings in return for donating funds to councils and unions. Jailed in 1973, the swimming pool in Buxton was completed by Booth, Hancock & Johnson of Pontefract – Poulson's successor company.

The pool was opened on 16 November 1972 in a ceremony by Princess Anne. Initially, the pool was filled with a proportion of thermal water, but this changed as the complex expanded and a fitness centre was added.

In the nineteenth century the area where the present pool stands was purposely flooded during the winter months. A rink was created and, as it froze, it hosted ice skating and curling tournaments. In the summer months the rink was used for roller skating. Building the swimming pool on this site perpetuates its use as a place for public recreation.

48. Fire station, Ashbourne Road, 2011

The Fire and Rescue Centre is a state of the art building and incorporates many renewable energy methods designed to keep down carbon emissions and reduce running costs.

The fire station, Ashbourne Road.

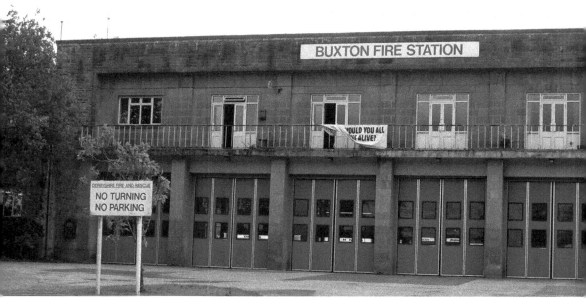

The previous fire station on Compton Road.

This permanently manned £3.5 million construction offers unsurpassed training to Derbyshire firefighters and the county's cave and mountain rescue teams.

The fire station is sited on the Staden Lane industrial estate and the building replaced the earlier one on Compton Road. A Victorian fire station – ironically constructed of wood – had served Buxton before the need for a station big enough to house large vehicles. Opened in the early 1960s in the middle of a housing estate, the Compton Road station also became inefficient due to its lack of size and increasing access problems. The new station houses eight fire engines and has good road access to the town and surrounding area. The Compton Road site sold for £1.5 million and has been used for a housing development.

The new fire station is made of modern construction materials throughout. However, it has been clad in stone to correspond with the style of many municipal Buxton buildings and is an attractive addition to its area.

49. Nestlé Factory, Waterswallows, 2012

People have been drinking Buxton mineral water for millennia. The water at source is 5,000 years old and rich with minerals. The ability to drink from the natural springs in the town has traditionally been free for all, until the Pump Room was opened in 1894. Inside, people were charged a penny a glass to drink the water in private surroundings. The concept of selling Buxton water grew and in 1912 water was being bottled from St Anne's Well and sold to a wider area. By 1955 Buxton Mineral Water was a well-known brand, being produced in a small premises on George Street.

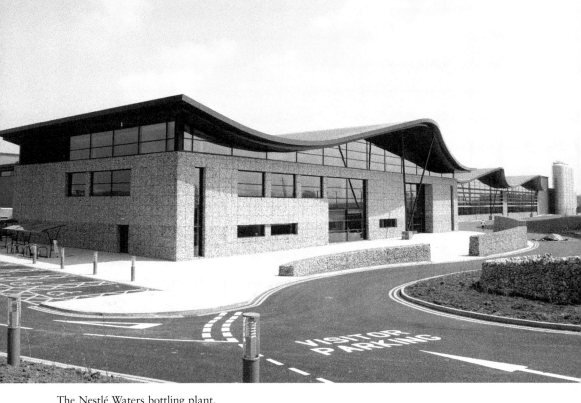

The Nestlé Waters bottling plant.

The Buxton Water Company was sold first to Canada Dry Rawlings and then it was bought out by Perrier. When Nestlé took over the bottling of Buxton Spa water they developed the product into a global brand. Nestlé's original bottling plant was situated in the town centre near the railway station, but this ceased to be large enough and so a new site was found.

Pochin Construction started work on the £35 million state-of-the-art factory at Waterswallows in 2011, and by May 2012 the first bottles rolled off the production line.

The factory is very environmentally conscious. The building has a waved roof. This is designed to be attractive to the observer as it can blend into the gently undulating hills of the Buxton countryside. The waved design also draws on the influence of some of the Arts and Crafts properties in Buxton, particularly the church of St Mary the Virgin. The walls were all built using recycled drystone walls, and drystone walling has been used to mark the site perimeter. Local craftsmen and workers were used to boost the local economy. Any power and heat sources are low energy and the greenhouse gas emissions of the plant are at a minimum. The company also has a zero-landfill waste policy and their rainwater recycling system is innovative. Designed to mimic nature, Nestlé have said that if the rainwater on the site is allowed to drain naturally into the earth, it's just possible that in 5,000 years this same rainwater will have absorbed local mineral deposits and become the very mineral water that they collect and bottle now.

50. Haddon Hall Care Home, London Road, 2014

Haddon Hall Care Home is a newly built seventy-five-room property designed and engineered by DWA architects. This property replaces the previous Haddon Hall that was destroyed by fire in 2010.

Designed in the 1880s, the Haddon Hall Hydropathic Establishment used to stand on the site. It was built as part of the hydropathic boom, when many new hotels and hydros were created in Buxton. In the late Victorian era, the railways increased the volume of tourists wanting to visit the town to take the waters, and town planners needed more accommodation to cater for them. In 1903, another hydropathic hotel was built on the adjoining plot, this was known as the Haddon Grove Hydro.

Richard Freckingham set up Haddon Hall Hydropathic. It had forty-one bedrooms and two sets of baths. For the sum of 30s a week to cover board, lodging and treatment, visitors could enjoy 'one of the healthiest parts of Buxton where there is a good supply of good

The Haddon Hall Care Home, London Road.

water'. The two establishments existed side by side for some years, competing for trade. In the 1920s both hotels were sold to the same company and joined together under one management. The extended building became Oliver's Haddon Hall Hydro. In the 1930s the advertising for Oliver's hydro mentioned it had 'a garage for 30 motor cars, hot and cold running water in all bedrooms and a lift'.

Following the decline in the popularity of hydropathic treatments in the 1950s, the combined building was acquired by the Central Electricity Board. It was used by them as a centre for residential training courses and renamed Electricity Hall. The industry was denationalised in the 1980s and the building was converted. The property became flats and bedsits for students, but it was soon forced to close due to inadequate fire precautions.

The building remained empty for some years, although it was sometimes occupied by squatters and it is possible that it was squatters who caused a major fire in 2010 that led to Haddon Hall being demolished in 2012.

The earlier Haddon Hall.

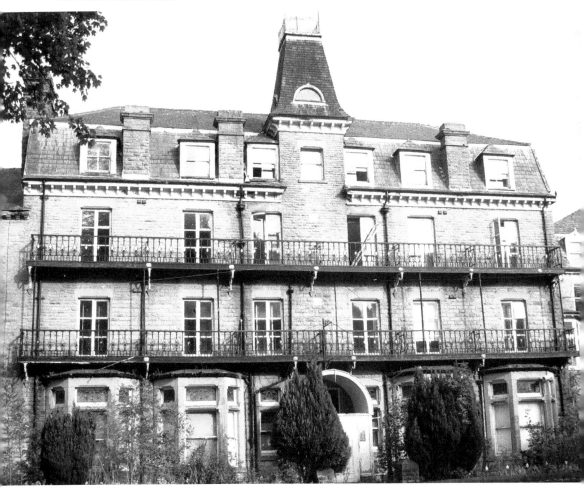

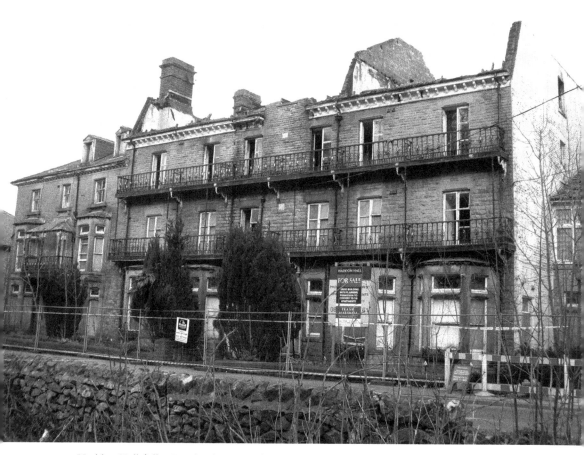

Haddon Hall following the disastrous fire.

The new Haddon Hall was opened in June 2015 by Angela Rippon. She remarked that the home 'fits in well with the local vernacular'. This is true. The building is faced with stone and its simple slate roof had elegant gables. Although the Victorian Haddon Hall had a mansard roof and a more obvious French chateau-style design, there are great similarities between the two buildings – even the original metal balconies have been reflected in the styling of the new main entrance. The architects have sympathetically designed the building to reflect the heritage and inspiring architecture that makes up the town of Buxton.